The
PHOTOGUIDE
to
Enlarging

Günter Spitzing

Focal Press

London & New York

Translated by Fred Bradley, FRPS, AIIP
from Vergrössern—Schwarzweiss+Farbig

© Verlag Walther F. Benser, KG 1969

First edition 1973
Second impression 1974
Third impression 1975

ISBN 0 240 50760 6

Printed by Biddles Ltd., Guildford, Surrey
Bound in Great Britain by
The Pitman Press, Bath

Contents

Photograms
and
Contacts

Have you never processed a photograph yourself? Are you still without any darkroom equipment? Then this first chapter has been specially written for you. I am going to tell you something about a few special darkroom practices; they all have one welcome feature in common: they cost very little.

Materials for photogram experiments

Photograms are not prints. They are the outlines of small objects created by light on photographic material. Basically they are photographs taken without a camera. They do not require an enlarger either. Seven items are necessary to produce photograms.

1 A 15W clear bulb.
2 A yellow-green darkroom safelight bulb.
3 A small bottle of concentrated developer, to be diluted with water to make 1000 cc, or developer powder.
4 Rapid fixing salt (for 1000 cc)
5 Two developer tongs (if you do not want to get your fingers wet).
6 A glazing sheet as used in a dryer-glazer (minimum size 19 × 24 cm or 8 × 10 in), or a smooth Formica sheet, a mirror, or a sheet of glass, and a roller squeegee.
7 A packet of printing paper – white, glossy bromide paper of normal contrast grade in post-card size or 13 × 18 cm format.

You are now ready to start.
Set up four shallow dishes in a darkened room – bathroom, cellar, attic, dining room (cover the table with a plastic sheet); at a pinch you may use soup plates. Plastic vessels are eminently suitable as provisional developing dishes. You must, however, make up developer and fixing solutions in vessels that take at least 1000 ml of solution, e. g. well-cleaned l-litre wine bottles. The developer stock solution is poured into the bottle, the bottle filled brimful with water, closed with a cork, and inverted several times to mix the solution thoroughly.
The developer is now ready for use. Its temperature should really be 20°C, but for your first experiments it does not matter very

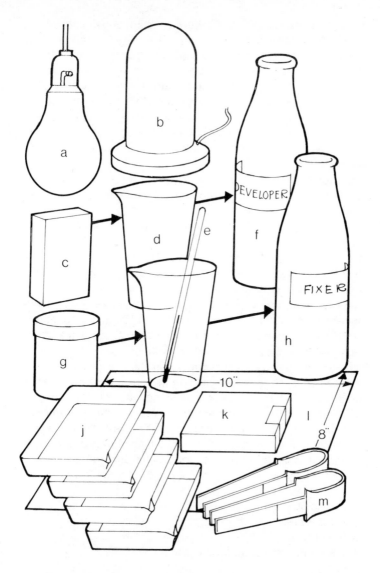

Basic equipment for photograms: **a**, 15-watt lamp. **b**, safelight. **c**, developer powder. **d**, beaker. **e**, thermometer. **f**, made-up developer solution. **g**, fixer powder. **h**, made-up fixing solution. **j**, processing trays. **k**, paper. **l**, glazing sheet. **m**, print tongs.

much. One litre (1000 ml), by the way, is enough to develop 200 to 250 postcards. The yield of rapid fixing salt is not quite so great: 100–125 postcards is the limit. This means you will use two volumes of fixing solution for every volume of developer. In theory, you could make up your fixing bath also in a wine bottle. But there is the practical difficulty of pouring the powder through the narrow bottleneck. I would therefore advise you to use a milk bottle for the fixing solution, at least to begin with. Unless, of course, you work with concentrated (stock) fixing solution. This, too, is available from dealers.

Don't forget to label these bottles clearly; after all, their legitimate use is for beverages, and a swig from the wrong bottle might have unpleasant consequences.

Made-up chemicals should of course be kept in a safe place – well away from where children can reach them.

The rapid fixing salt is poured into 750 ml water, which must be stirred vigorously all the time. As soon as the salt is dissolved, the solution is made up to one litre.

The fixing powder, when it is poured into the water, has a tendency to produce dust; this dust is harmful to the developer, the bromide paper, and the furniture. I for one always make up my fixing solution outdoors, in the garden.

I can only advise you never in any circumstances to make up your fixing solution in the room you use as your darkroom. Suitable for this purpose are the balcony, landing, attic, cellar, or sill of a wide-open window. After the baths have been made up they are conveniently arranged. A serving tray lined with plastic foil, for instance, is a very handy aid; it can be placed over a bathtub or washbasin. Your four dishes or soup plates are arranged on it as follows:

1 Developer
2 Water (intermediate rinse)
3 Rapid fixer
4 Water (for collecting the prints).

Do not fill the dishes to the brim; if you do, the solutions will spill over as soon as you agitate the prints.

The work room must of course be completely blacked out. In an

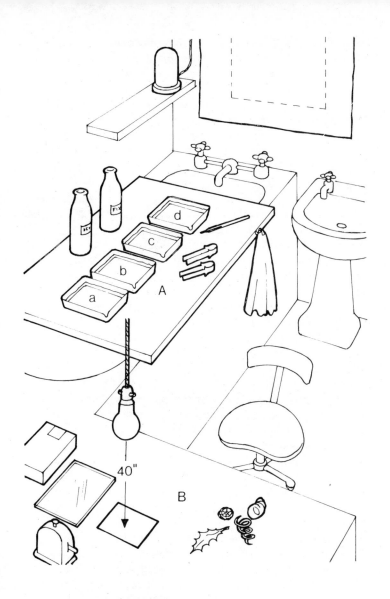

40"

Darkroom layout in bathroom: A, wet bench. B, dry bench. The processing trays are: **a**, developer. **b**, stop bath. **c**, fixer. **d**, water for collecting processed prints awaiting final wash.

extreme case the only way to overcome any difficulties here is to postpone your darkroom activities until the late evening. When I said that the room has to be blacked out, I did not mean that it has to be pitch dark. Only the daylight has to be kept out. Your working area should be illuminated with a yellow-green darkroom safelight. This is comparatively bright but does not do any harm because bromide paper is rather insensitive to it; a distance of 1 m (40 in) should, however, be kept between the darkroom safelight and the baths.

Now you need another working area where you can expose your bromide material. Make sure to keep the exposure and processing areas well apart. Splashes of chemicals on the exposure area take the fun out of darkroom work.

A table or a writing desk can serve as a work place for the exposure. A clear-glass household lamp must be suspended directly above it at a decent height. The greater the distance between the working area and the lamp the better for your photograms: the sharpness of your pictures depends on it.

My experiments have shown me that photograms will still be sharp with the lamp suspended 1 m (40 in) above the bromide paper. It must of course be possible to operate the lamp from the working area.

The box of bromide paper may be opened in the light from the yellow-green darkroom lamp, but the paper itself should never be left lying about openly; even the yellow-green rays can spoil it if they are allowed to act on it for prolonged periods. It is best to take only one sheet of paper from the box at a time and to keep the rest light-tight in the box. The paper to be processed is spread on the working area, emulsion (shiny) side upwards. Unfortunately the sheet will quite often curl slightly. To prevent this, weight the corners with heavy objects. Two heavy tomes, each covering a narrow strip along the short sides of the paper, will ensure that the paper lies perfectly flat on its support. Obviously, the areas of the paper covered by these objects will not be exposed and are therefore eventually trimmed off.

Your work finished, store your bromide paper in light-tight conditions. If the developer is not yet exhausted, return it to its bottle; but use it up completely within a week, because partly-used developer decomposes spontaneously.

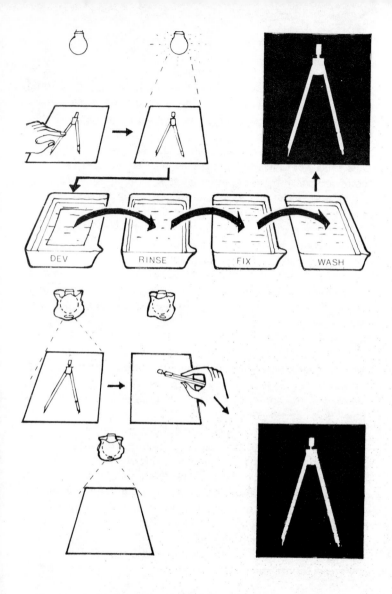

The simple photograph (top) shows a white shape on a black ground. Tones can be introduced (bottom) by giving a short extra exposure after removing the object from the paper.

15

Making photograms

You are now ready to arrange small objects on a sheet of bromide paper in the light of your yellow-green darkroom lamp. I should like to classify such objects in three groups, because each of them calls for slightly different treatment as regards exposure:

1 Opaque or almost opaque objects, such as paper clips, safety pins, nails, screws, tools, parts of dismembered clocks and transistor radios, metal jewellery, matches, wooden laundry pegs, wickerwork, wool threads, rope, rubber rings, buttons, chessmen, toys, bare branches, twigs.
2 Translucent objects, such as leaves, grass, flowers, feathers, fabric, ribbons, lace, letters written on one side, documents, engravings, stamps, pearls, photographs.
3 Transparent objects, such as pieces of glass, liqueur glasses, flashbulbs, radio valves, glass jewellery, crumpled cellophane, transparent plastic containers, textured glass, dessert plates, soap on a glass plate.

Groups 2 and 3 will be discussed in more detail later. Let us start with an opaque object for our first photogram. What about a small pair of pliers? Or a silver chain? Or a pair of compasses? Let's settle on the compasses and place them on the light-sensitive paper.
Now switch the light on, slowly count up to three, and switch it off again. That is the exposure; next comes the processing.
Immerse the sheet of paper, emulsion side upward, in the developer as deeply as possible with one of the pairs of tongs. Make sure that the entire surface of the paper is wetted by the developer. Turn the paper emulsion side down and push it to the bottom of the dish twice or three times; turn it round again to inspect the progress of the development.
By now the blackening process has already begun and, in the yellow-green light, you are able to watch it quite clearly. The surrounding area will, to start with, turn light grey, and rapidly turn darker and darker. Only the silhouette of the pair of compasses remains white, standing out more and more clearly from its surroundings.

The way such a print gradually builds up never loses its fascination. But we have no time to spare for this – development is complete after little more than two minutes, and the paper must be transferred to the intermediate rinse. Fortunately this is not a matter of seconds, even half a minute makes no difference. But if you wait longer than five minutes, the portions that should remain white will acquire a muddy, yellowish or grey tone which is horrible to look at.

To transfer the print to the intermediate rinse, take up a corner of it with the developer tongs, and lift it to let the developer solution drain off for about 15 seconds. Otherwise too much developer will be carried over into the other baths. Never immerse the developer tongs in the intermediate water bath.

Thoroughly agitate the print in the water with the fixing tongs for about 30 seconds. Then lift the print with the tongs, let the water drain off for 15 seconds, and transfer the print to the fixing bath, where it should remain for 3–4 minutes. Here, too, the time is not critical. At the beginning, and occasionally later, agitate the print vigorously. After 20 seconds you may switch on bright light for a thorough inspection of what you have achieved.

When the print is thoroughly fixed, lift it and let the fixing solution drain off, and transfer the print to the final water bath. This dish should be used for the temporary collection of all your prints. As soon as you have finished your "photogramming" session, you can transfer the lot to running water for washing and then dry them (see p 97).

How the image is formed

Such an exposure and processing experiment is much more quickly and simply carried out than described. The most difficult thing to explain is what has happened in the photographic emulsion. Since the theory of the developing process is of no practical significance I am confining myself here to a brief explanation of the various features.

The light-sensitive layer of photographic papers and films consists of finely distributed, minute silver bromide grains embedded in gelatine. During exposure the light rays affect the entire paper

except the parts covered by the compasses. This irradiation makes the silver salts exposed to it developable, i. e. they can be reduced to metallic silver by the action of a suitable developer. This means that the outline of the compasses is already fixed on the paper in the form of unexposed salts in a surrounding field of exposed ones. But we can see nothing of this state of affairs immediately after the exposure; the image is latent.

The developer has the task of reducing the exposed silver bromide crystals to silver and bromine particles. The latter are taken up by the developer whereas the former remain on the surface of the paper as a dark deposit. The exposed surrounding field has thus become black during development. But the developer has no – or, more precisely, little – effect on the unexposed, stable silver bromide. If you switched the light on now, the previously unexposed portions, too, would darken. The developer is therefore washed off and the print transferred to the fixing bath. This does not attack the blackened portions, but converts the hitherto unexposed silver bromide into water-soluble salts, which are washed out during the final rinse.

Variations in treatment

In your experiment it is not very important how long you expose the paper for. If the exposure is too short the background will turn only grey; a 15 W lamp is, however, bright enough to blacken the surrounding field completely within as little as $1/2$ second. I therefore wrap it in black paper (bromide paper wrappings) into which I cut a hole of about 18 mm diameter. This reduces the strength of the light to enable me still to obtain definite grey values at exposure times of $1/2$, 1, $1^1/2$, and 2 seconds. The shorter the exposure the lighter – obviously – the grey. Here is an interesting version of this experiment: expose the surrounding field generously so that it turns black. Now remove the object in the dark, and switch the light on for about another $1/2$ second. Result: a grey object in front of a black background. If the first exposure, too, is kept very short you will have a light grey pair of compasses on a dark grey background. (Try, to begin with, to keep both part-exposures within the order of $1/2$ sec.)

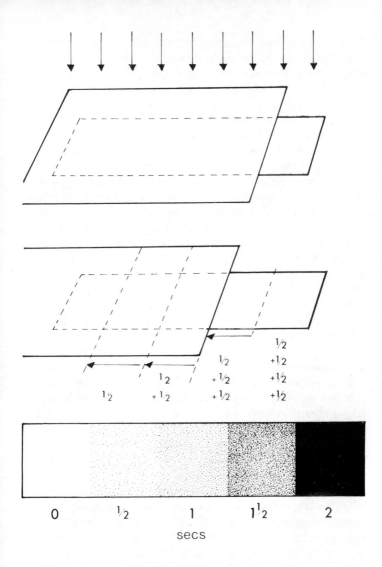

½

½
+½

½ ½
+½ +½

1₂ 1₂ +½ +½

1₂ +1₂ +½ +½

0 ½ 1 1½ 2

secs

Printing paper is rapidly affected by light. A test strip giving successive half-second exposures shows the range of tones you can produce.

19

If all you want is jet black and brilliantly white tones, guessing your exposure time will be quite adequate; but if you aspire to grey tones, exposure times must be precisely matched.

Another variation of the compass picture: make two or three part-exposures. Between each exposure either move the compasses a little to one side, or place them in a completely new position on the paper, or slightly change the angle of the limbs.

The permanently covered portions of the paper remain white, those that were exposed once are light grey, those with two exposures medium grey. The three-times exposed surrounding field will be dark grey to black. If a grey value turns out too dark, the individual exposures must be slightly cut down. More than three exposure steps call for extremely short exposure times. Here you should not allow the background to "plunge" completely into black. Otherwise some of the grey values will become so dark that the contrast with the surrounding field is no longer strong enough. To avoid undue waste of enlarging paper on unsatisfactory prints, make trial exposures of $1/2$, 1, $1^1/2$ and 2 second on a strip cut from a postcard-sized sheet. (Cover the strip except for a small portion with a book; expose $1/2$ second; uncover another portion, expose another $1/2$ second and so on. If you fail to obtain satisfactory grey steps, either extend or reduce the individual exposures accordingly). A perfect assessment of the grey values of this so-called step wedge is possible only in bright light switched on after 20 seconds' fixation. Judgment in the yellow-green darkroom light is unreliable.

Factors affecting tone and sharpness

There are a number of solid, opaque objects which do not necessarily always produce a purely white picture even after a single exposure. Think, for instance, of a pine twig. The needles directly lying on the paper leave white silhouettes behind; but those parts of the twig which rise a little above the paper will sometimes be reproduced light to dark grey after very prolonged exposure.

At the same time there may be a difference in sharpness between the needles in and those out of contact with the paper; this depends on the light source. A simple bulb or the light beam of a

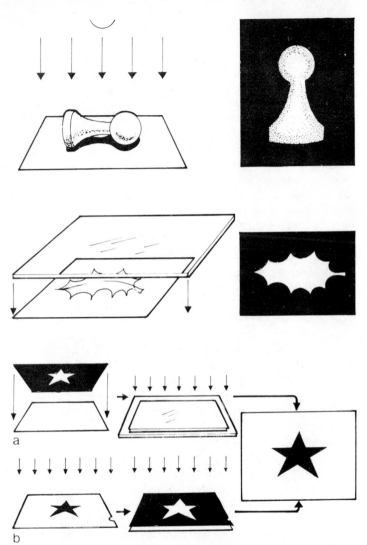

Three-dimensional objects (top) show differences in tone as the light creeps round them. To obtain a clear photogram of a leaf or similar object (middle) you press it flat with a sheet of plate glass. Black on white versions are obtained (bottom) by making a photogram on paper (a) or film (b) and contact printing on to another sheet of paper.

projector makes sure that all parts of even a large object produce a fairly sharp image. The situation changes radically as soon as you enlarge your light source, for instance by placing an opal glass bowl over the bulb, or by creating a large luminous area with a sheet of flimsy paper held above the object.

Such manipulations with the light source result in some of the needles forming unsharp pictures, because:

The longer the distance between object detail and enlarging paper, the less sharp the picture.

The larger the luminous area of a light source and the shorter its distance to the object, the more blurred will be all those object details which are not in direct contact with the paper.

Sharply outlined photograms therefore require a light source with the smallest possible luminous body and at the longest possible distance.

But the interplay of sharpness and unsharpness and of the various shades of grey, too, has its attractions. I personally prefer sharp outlines. I do, however, consider some combination of sharp and unsharp photograms interesting in the extreme. I first expose a rounded body, a chessman, say, to "sharp" light, perhaps from an electronic flash unit masked down to a small beam. For the second exposure I cover the subject with a sheet of paper. This produces soft, diffuse light.

The pictorial effect: within a pin-sharp outline the object details will become more or less grey – at least if they were not lying directly on the paper. The marginal zones of the silhouette are most strongly affected.

Photograms of translucent objects are most attractive owing to the rich tonal range of their grey values. This calls for careful assessment of the exposure time (consult your step wedge).

A special case is the photogramming of leaves, grass, and some flowers. After a short exposure they leave merely white silhouettes on the paper. Structural detail can be made visible only by generous exposure. The major part of a leaf structure, however, will appear unsharp because the light is strongly diffused in the leaf. Only the parts of the leaf surface in direct contact with the bromide paper will leave a clear outline.

Detail rendering can be slightly improved by means of a glass plate with which the object is pressed against the paper.

The treatment of transparent objects should be similar to that of translucent ones. Bundling or refraction of light, however, occurs quite often, for instance in glass (whole or in pieces); this results in light dots that are considerably brighter than the evenly illuminated field surrounding the object. If you adjust the exposure for a grey tone, the light dots, reproduced in black, will provide a contrast.

Opaque but sparkling objects, by the way, sometimes also produce extremely bright light reflections. These, too, may by similar methods be rendered considerably darker than the surrounding field.

Practical applications

I almost forgot to tell you about the practical uses of photogramming:

1 Those interested in botany can obtain a collection of characteristic outlines of leaves. A catalogue of lace patterns, for instance, can also be produced by the photogram technique.

2 Arrangements of decorative patterns. Paper clips, chessmen, rubber rings and other small objects are the components for attractive ornamental compositions. Possibilities of variation through multiple exposures or screen foils.

3 Figure compositions. Small details – nails, screws, buttons, parts of a dismembered alarm clock – can be arranged to form figures on the bromide paper.

Photograms with black figures

Three methods can be used for the production of "positive" photograms – black figures on a white background:

1 Simply photograph an ordinary photogram. Result: a black silhouette on the negative. It can be made into a slide and projected on a screen. To produce a paper print of black figures, however, a genuine transparency (white on black) must first be obtained

from the negative. The final paper print is produced with the usual enlarging technique. A simplified procedure is to photograph the photogram on black-and-white – or even colour – reversal film. The finished transparency is simply inserted in the enlarger.

2 A paper photogram is placed on the bromide paper, emulsion side facing emulsion side. This sandwich is covered with a sheet of glass. Press the sheet down firmly with both hands. Wherever the two emulsions fail to make perfect contact during the exposure, the finished print will be unsharp. All you do is use the finished photogram as an object for a new photogram.

3 The photogram objects are arranged on sheet film or plates. The finished film photograms are in turn placed on bromide paper and exposed. This is a particularly attractive method. Difficulties with grey tones can hardly arise. All materials suitable for the production of transparencies from negatives are also suitable for this method.

Making contact sheets

For years, indeed for decades I looked down my nose at contact sheets, and therefore never printed any myself. Only after I had begun to write this book did I have to lower myself to experiment with contact sheets. To write a book on darkroom practice without mentioning contact sheets at least a couple of times is just not right.

I started with a film of which I had already enlarged all the worthwhile negatives – or so I thought. When the contact sheet suggested to me that I should enlarge three more negatives I had up to then completely misjudged I sat up and took notice. I made a whole series of contact sheets of other negatives – always with similar results.

This gave me food for thought. I began to regret that I had not made a contact sheet of every film right away, and am now faced with the unenviable task of producing one of each film in my not exactly small negative archive. I am going even further now: I make black-and-white contact sheets also of colour negatives as a matter of routine. The finished sheets are punched and filed behind the associated negative storage sheets.

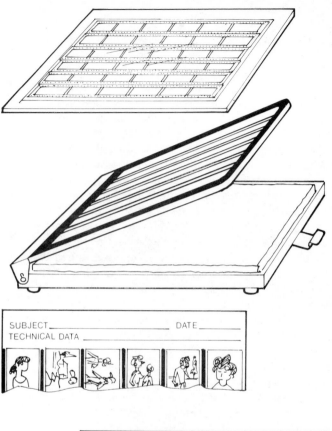

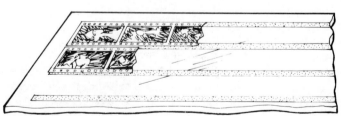

Contact sheets are useful for reference. You can place strips of film on large sheets of paper (**top**), hold them flat with plate glass and expose by ordinary lamp or enlarger beam. Commercial models (**middle**) print reference headings on the sheet. Double-sided adhesive tape (**bottom**) can be used on do-it-yourself models.

25

The contact prints need be neither correctly exposed nor free from dust spots. Contact sheets are, after all, only a means to make the selection of negatives for enlargement easier. No matter how experienced a photographer you are, to judge the effect of a picture from the negative alone is always risky.

The standard material for contact sheets is soft, white glossy 18 × 24 cm (8 × 10 in) enlarging paper. Normal paper is unsuitable, because negatives on any one film will usually be different in density and different in contrast; this creates the risk that only a few pictures could be judged correctly. Some of the frames would come out too light, almost white, others too dark, almost black. It is true that soft paper makes the pictures on the whole appear a little flat; but this ought not to irritate you. The main thing is that both unusually light and unusually dark pictures are readily judged. Soft photographic material has, after all, inherently a much greater exposure latitude than harder material.

Although soft paper will tolerate fairly wrong exposures, there are of course limits beyond which you must not go. Rather than spoil one or two whole 18 × 24 cm (8 × 10 in) sheets you should make a test exposure on a small piece of the same photographic paper – a so-called trial strip. The trial strips and the contact sheets are processed exactly like photograms.

An 18 × 24 cm (8 × 10 in) sheet accommodates six strips of six 35 mm negatives (a negative storage sheet takes six strips of six 35 mm, three 6 × 6 cm (2¹/₄ × 2¹/₄ in), or two 6 × 9 cm (2¹/₄ × 3³/₄ in) negatives; normally strips are therefore cut in these lengths). It is, however, necessary for the perforations of the 35 mm negatives to overlap on 18 × 24 cm paper, otherwise the width of 18 cm (7.2 in) will take only 5 strips.

An 18 × 24 cm (8 × 10 in) sheet also offers enough space for a whole 6 × 6 cm (2¹/₄ × 2¹/₄ in) or 6 × 9 cm (2¹/₄ × 3³/₄ in) film. The (matt) emulsion side of the film must be in direct contact with the (glossy) emulsion side of the paper; the films should not curve excessively; although perfect contact between the emulsions is best, a slight air gap between the transparent negative and the support does not neccessarily cause objectionable unsharpness. In this respect the copying of translucent originals such as photograms or enlargements on paper or opal film is much more critical.

I sometimes use a sheet of glass to press the film flat on to its support. But I am not very fond of this method, because I am afraid of impressing dust grains into the back of the film by doing this; such grains are difficult to remove.

A way out is to press only the two ends of the negative strips on the paper with heavy books; if you are the owner of a masking frame for enlarging, its masking strips perform the same function. Your negatives will now be perfectly flat.

Making black-and-white transparencies

If you already have a small archive of slides and a projector, there is no reason why you should not make slides of your black-and-white negatives. This you can do on sheet film or lantern plates. A disadvantage of the lantern plates is that they are breakable but there is another reason why I now greatly prefer sheet film: the negative has to be placed downwards on the sensitive material so that its matt, emulsion side faces the upward-facing emulsion side of the sensitive material. Now it is by no means easy to ascertain in the yellow-green light whether the negative is really exactly in the centre of the lantern plate. Again and again I failed to notice until the transparency was finished that the picture was off-centre, the horizon sloped or a spire toppled. It is impossible to correct this on a glass plate. With a film transparency, on the other hand, the negative need not be aligned at all.

The finished transparency is simply trimmed and carefully fitted in a frame.

Another advantage is that I use sheet film mainly in the 13 × 18 cm format. On these sheets I can comfortably spread ten and more 35 mm negatives and expose and process them together. This very time-saving method obviously calls for the arrangement only of negatives of the same or similar density on the sheet film. I do not use a glass plate to flatten those negatives that are already lying flat on the sheet film without this aid. Unfortunately some negatives don't. Here I try to weight their edges with coins. If even this does not produce the desired result, I reluctantly use small transparency cover glasses or – if I expose several transparencies at the same time – a larger sheet of glass; but I dislike

this method very much. Even without it, you have to contend with a problem that can all but completely spoil your enjoyment of black-and-white transparencies: dust. You must take great care to remove dust from both the emulsion side and the back of the negative. If you use a glass plate on top of it, this, too, must be completely free from dust. It is best to remove each of the offending dust particles individually with a fine sable brush. You will nevertheless not always be successful; every grain of dust will stand out on a black-and-white transparency with offensive clarity. With paper prints and even with the processing of colour transparencies dust presents far less of a problem. I don't wish to discourage you: only if you have the opportunity to inspect a 2 m (6$^{1}/_{2}$ ft) projected slide will you be able to notice what you can get out of such a seemingly humdrum negative. The only snag is this bugbear of dust. It is sometimes necessary to repeat a print two, three, even four times to get rid of the dust completely – only to find the white streak caused by a hair falling out of the sable brush. Moreover, the transparencies are most difficult to retouch. You will have noticed that I recommend very hard films for transparencies. Unlike the paper print, a transparency cannot be brilliant enough. This is an additional reason why I prefer sheet film, which can be obtained in contrasty versions.

Exposure should generally be adjusted to give a developing time of 3 min at 20°C. You must always adhere to the developing time exactly; it is impossible to judge the transparency visually in the developer. Only after 30–90 seconds in the fixing bath, when the milkiness has disappeared from the emulsion, can you see if the exposure was correct. For drying, films are hung up, plates stood on edge along the rim of a dish. Dry transparencies appear darker than wet ones. Should they appear too dark, they can fortunately be improved (see p 133). Too light or too flat transparencies are, however, beyond salvation.

Exposure tips for sharp negatives

We have discussed the most important possibilities of practising darkroom routine without much expense. It is time now to tell you how you can gradually set up a mini-laboratory that offers you

maximum scope. But this will be of use to you only if you have negatives that are really suitable for enlarging.

I have already said that you do not necessarily have to develop your own negatives. Poor negatives are occasionally spoiled during development, but most of them are already doomed at the exposure stage.

My first attempts at enlarging were confined to postcard size. Here I was able to evaluate even pictures I had taken as a boy with a box camera. But I soon realized that the fun of enlarging increases with the enlarging format. I changed over to 18 × 24 cm, which I would still call my standard format today. Occasionally I do, however, blow up my Leica negatives to 24 × 36 cm (10 × 12 in), 30 × 40 cm (12 × 16 in), 50 × 60 cm (20 × 24 in) or even larger.

But let us come back to 18 × 24 cm (8 × 10 in). I should like to call this the critical enlargement, because it is the smallest format that shows up mercilessly all the weaknesses of a negative. Few photographs taken with box and the simplest cameras, which occasionally may be good enough even for 13 × 18 cm ($\frac{1}{2}$-plate) enlargements, are acceptable when blown up to 18 × 24 cm (8 × 10 in). We might as well admit it: only these larger formats really reveal what a camera can do, or better still, what it cannot do. Talking of myself, I have been favouring for the last 15 years the Leica M3, and recently the Leicaflex SL. Nevertheless, the first pictures I took with this precision camera are useless except those taken with flash or from a tripod. In my innocence I had taken most of the photographs at $^1/_{30}$ sec. and, for the sake of great depth of field, f/16 in summer sunlight outdoors and hand-held. The negatives lacked the desired pin-sharpness.

These experiences have long made me sacrifice depth of field in pictures without tripod; I prefer instead critical definition of details of my subject. Anything in front or behind it is allowed to dissolve in a cloudy blur. I open the lens diaphragm wide to obtain the highest possible shutter speed. This is the only method that ensures sharp pictures with a hand-held camera. Shutter speeds below $^1/_{125}$ sec are out of the question for me. Only when lighting conditions leave me no alternative and I can find some support on which to prop my elbows I reluctantly use a slower shutter speed. If at all possible I expose at $^1/_{250}$ sec.

Another important influence on sharpness is the level of exposure and you would do well to use an exposure meter even with black-and-white negative film in your camera. Take your reading of the darkest portions of your subject still expected to show a certain amount of detail. All this having been said you must not ignore the fact that subjects without contrast permit exposures with the lens stopped down by up to one stop, and that contrasty ones (e. g. contre jour subjects) demand up to one stop larger. The reason why I dealt at some length with the subjects of high shutter speed and exact exposure is that the influence of these factors on picture definition is often still underestimated. What is overestimated on the other hand is the graininess of ultra-fast films and its effect on definition. Even ultra-fast films can be enlarged considerably without difficulty. The table below indicates the maximum enlarging ratio for a given film speed. It refers to wall-mounted and exhibition pictures to be viewed at a distance of about 1 m (40 in).

ENLARGING RATIOS RELATED TO FILM SPEED

Speed ASA	DIN	Maximum enlarging ratio	Picture size of 35 mm negative cm	in
25	15	1:40	96 × 144	38 × 58
40	17	1:32	77 × 115	31 × 46
100	21	1:28	67 × 100	27 × 40
400	27	1:20	48 × 72	19 × 29
800	30	1:16	38 × 58	15 × 23

My own experience with giant enlargements has shown me that the values of this table are by no means optimistic. On the contrary, I have made part-enlargements of ultra-fast films at considerably higher enlarging ratios. I was able to do this because the enlargeability of a negative depends to some extent also on the subject. The slightest lack of definition is already found disturbing in a picture of, for instance, a spider's web. Snapshots of a sports event or portraits are far less sensitive in this respect. Contrasty subjects or objects in front of a dark background appear sharper to the eye than subjects lacking in contrast or light objects in front of a light background.

The distance between viewer and picture has a most decisive effect on the degree of permissible unsharpness. If you "sniff" at a giant enlargement you will regularly discover unsharp portions. On the other hand, manufacturers of subminiature cameras (for formats between 8 × 11 mm and 12 × 17 mm) are very fond of showing 30 × 40 cm (12 × 16 in) enlargements on exhibition stands to give evidence of the excellent performance of their mini-instruments. These pictures appear indeed amazingly sharp – because they are mounted in such a way that the public cannot get closer than 2.5 m (8 ft).

When talking about sharpness we must not forget the role of the camera lens. Most lenses have their optimum resolving power at medium stops – about f5.6–f8, whereas top quality lenses show their optimum performance at a larger aperture. As long as the depth of field is adequate, opening up the lens beyond the optimum setting does little harm. Exaggerated stopping down can do much worse damage in this respect. It is true that a greater depth in space is rendered reasonably sharp; but often no more than reasonably sharp. The picture can suffer from a general lack of definition caused by diffraction.

All these "ifs" and "buts" fortunately apply only to giant paper enlargements. If you confine yourself to postcard size you may forget all about these difficulties. You may also ignore them when you take colour transparencies. Slightly unsharp colour slides, astonishingly, can be projected extremely large – thanks to our usually comparatively long distance from the projection screen. Conditions are similar with the television picture. If we watched it at the same distance at which we normally look at a paper print of the same size we would become distinctly aware of the lack of definition on the television image.

Darkroom
Equipment

I hope the preceding chapter has whetted your appetite for the practice of enlarging proper. I therefore want to advise you how, where, and with what equipment you can best set up your darkroom. All the most important pieces of equipment from the enlarger via the processing dishes and the bromide paper to the drying machines are discussed in a separate section. This is followed by various suggestions for complete outfits, starting with a corner in the bathroom, and ending with a super-de-luxe darkroom.

You will find among the not absolutely necessary, yet recommended pieces of equipment some which in the long run will save you a lot of money and time. For obvious reasons I, too, had to equip my darkroom slowly, step by step.

The enlarger

The centrepiece of your darkroom is the enlarger. Basically it is a type of projector. Normally, however, the negative is not projected horizontally on the wall, but vertically downwards. The image is produced on a sheet of bromide paper on the baseboard of the enlarger. The centrepiece of the instrument is the enlarging lens.

An enlarger consists of a baseboard, which supports a column on which an adjustable carrier arm is mounted. The arm suspends the enlarger head above the baseboard and moves up and down the column to allow the distance between the enlarger head and baseboard to be varied. The enlarger head consists of a lamphouse with lamp and mains cable. Other components are the condenser, the groundglass screen, the negative carrier with a clamping device, and the enlarging lens in a focusing mount. The lamp transilluminates, via the condenser system, the negative in the carrier and allows its image to be formed by the enlarging lens on the baseboard of the enlarger. The focusing mount has the task of varying the distance between the enlarger lens and the negative; this adapts the focusing to the position of the enlarger head above the baseboard.

The shorter the distance between the enlarging lens and the baseboard, the longer the distance between the enlarging lens and

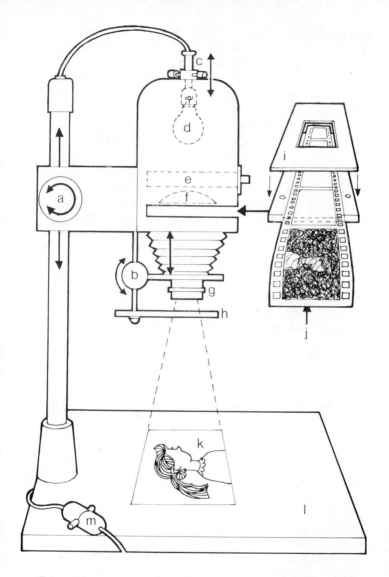

Enlarger features: **a**, head elevation lock. **b**, fine-focusing control.
c, lamp adjustment. **d**, lamp. **e**, filter drawer. **f**, condenser. **g**, lens.
h, swing filter. **i**, negative carrier. **j**, negative. **k**, projected image.
l, baseboard. **m**, lamp switch.

the negative. To make transparencies a 1 : 1 projection, or even a reduction, is sometimes necessary. In enlargers, however, the lens extension cannot be increased except with the aid of one or two extension rings or tubes, to be screwed in between lens and lens mount. When buying an enlarger make sure that it accepts such extension rings.

Whether you buy a high-quality enlarging lens or use the bottom of a milk bottle depends above all on your finances; but you should also include the quality of your camera in your considerations. Let us assume you are using a very simple camera. This produces negatives you want to enlarge to postcard size. Here the purchase of a high quality enlarging lens would be sheer waste of money; it could not reproduce negative detail that has not been resolved by the camera lens in the first place.

In this situation you ought to buy the cheapest lens you can find. But let us assume you are the proud owner of a high quality camera and that you use it correctly to obtain sharp pictures on your film. To save on the enlarging lens in such a situation would be utterly foolish. After all, you have gone to every trouble and expense to produce a satisfactory negative. You will endanger everything you have gained unless you buy the best possible enlarging lens. Enlarging lenses are, in fact, much less expensive than camera lenses in the same quality range, if only because their maximum relative aperture is as a rule much smaller. They are in any case stopped down to f 8, and better still f 11 for the exposure of the bromide paper.

You may be interested to know that good enlarging lenses can be used with excellent success as taking lenses for the close-up and the macro range as well as for copying. They are computed specially for close range work and can often produce sharper close-up and macro pictures than the ordinary camera lenses, which are corrected for infinity. Adapter rings and some ingenuity may be required to attach enlarging lenses to rangefinder cameras but there is no particular problem with reflex models. Conversely the use of high-quality camera lenses may sometimes be indicated for extreme enlargements (from 15 : 1 or 20 : 1). Occasionally this cannot be done for lack of suitable adapters. The focal length of the enlarging lens depends on the negative format, as indicated in the table.

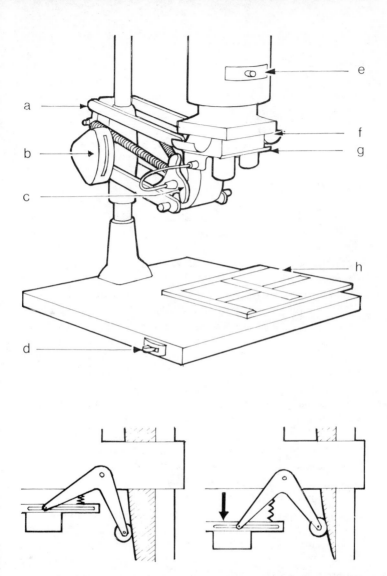

Advanced enlarger features: **a**, head-supporting arms. **b**, magnification indicator. **c**, automatic focus cam. **d**, lamp switch. **e**, filter drawer. **f**, negative carrier. **g**, interchangeable lens panel. **h**, integral multiposition masking frame. The bottom illustrations show a simpler form of automatic focusing device.

ENLARGING LENS FOCAL LENGTHS

Format	Suitable range of focal lengths
35 mm (24 × 36 mm)	45– 60 mm
6 × 6 cm (2¼ × 2¼)	75–100 mm
6 × 9 cm (2¼ × 3¾)	90–105 mm
9 × 12 cm (¼-plate)	135–180 mm
13 × 18 cm (½-plate)	180–240 mm

It would be nice if all enlargers could be adapted for many different negative formats simply by a change of the enlarging lens. Unfortunately difficulties stand in the way. Although the negative mask outlining the negative area can as a rule be exchanged, the limited dimensions of the condenser system (condenser or groundglass screen) is an obstacle.

A miniature enlarger accepts the 35 mm (24 × 36 mm) and 28 × 28 mm formats and usually also the so-called super-slides of 38 × 38. In addition all the small formats, and, of course, parts of 6 × 6 (2¼ × 2¼ in) and 6 × 9 cm (2¼ × 3¾ in) negatives can be enlarged. All 6 × 6 cm enlargers are adaptable for smaller negatives and also accommodate only slightly reduced portions of 6 × 9 cm films. Enlargers for the 6 × 9 cm and larger formats are rather expensive. Some large format (9 × 12 cm and 13 × 18 cm) cameras can be converted into enlargers by combination with a so-called cold-light attachment (lamp housing with gas discharge lamp).

There are various types of light source used in enlargers. The three most commonly used and their advantages and disadvantages are tabulated on p 40.

The negative carriers of miniature enlargers either press the negative between a glass plate and the condenser, or they consist of a simple negative mask in which the unmounted negative has space to move. It tends to do that – it pops – under the influence of heat. To prevent unsharpness in the projected image of the negative the enlarging lens must be considerably stopped down. The negative held between glass, on the other hand, occasionally conjures peculiar ring-shaped patterns, the so-called Newton's Rings, on the bromide paper. I prefer the glassless arrangement.

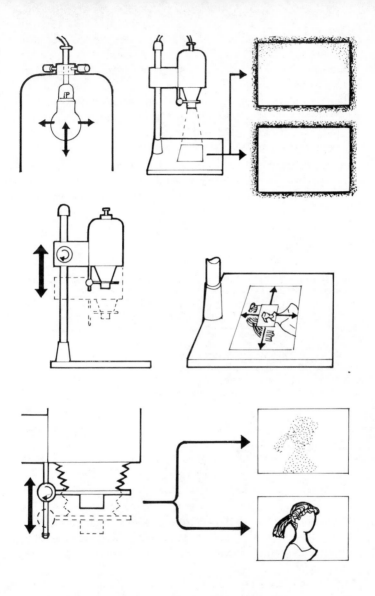

Adjustments are provided on most enlargers for (**top**) lamp position to provide even illumination, (**middle**) enlarger head to alter image size, and (**bottom**) lens extension to provide fine focusing.

But for larger negative formats the glass sandwich is indispensable.

Simple enlargers must be focused by hand. If you want to spend a little more, I would recommend an auto-focusing enlarger. When the enlarger head is raised, the lens is automatically moved closer to the negative stage. When the enlarger head is lowered, the distance between lens and negative stage is increased. The automatic mechanism must, however, be disengaged for enlarging scales above 10 : 1 and for reductions. A red filter to be swung in front of the enlarging lens is available as an accessory or, more often, is built in as a standard feature. It allows you to

ENLARGER LIGHT SOURCES

Light source	Advantage	Disadvantage	Remarks
Point source in clear-glass bulb with reflector and condenser	High luminous density. Contrasty rendering	Emphasizes dust and scratches on the negative. Even illumination only when lamp is accurately centred	In special cases
Opal lamp in matt – white housing. Condenser	Adequate brightness. Contrast not exaggerated. Scratches and dust are not unduly emphasized	—	In most miniature and 6 × 6 cm enlargers
Diffusing groundglass screen	Dust and scratches are suppressed	Weak illumination. Contrasts are suppressed	Mainly in large-format enlargers, especially with cold-light attachment

project an image on to the enlarging paper without actually exposing the paper. As the filter is both cheap and very useful for certain enlarging tricks you should include it in your outfit as a matter of course.

Another point to remember: although you may wish to start with black-and-white work, I daresay one fine day you will feel the urge to take up colour enlarging; you will be very annoyed if your enlarger cannot be converted for colour work. When buying it make

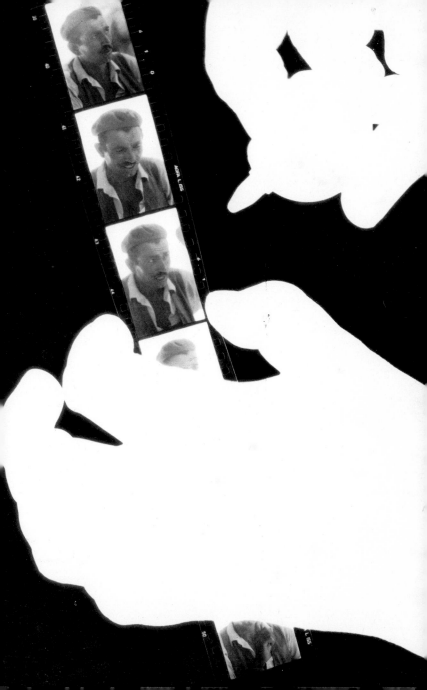

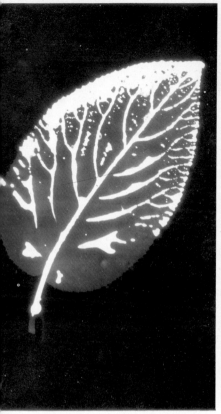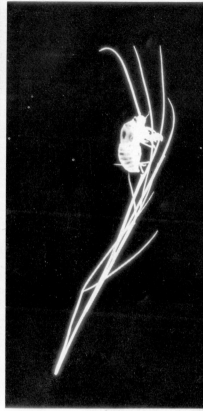

Left: A leaf wetted with fixing solution was pressed on bromide paper and exposed for a few seconds. The leaf was then removed and a short second exposure made so that parts of the leaf turned grey. The paper was then developed and fixed as usual. *Right:* Photogram of the case of a cicada chrysalis adhering to a blade of grass.

Opposite: Contact sheet. Six 35mm film strips of six exposures each can be accommodated on a 10 x 8in sheet of bromide paper.

Page 41: Photogram plus contact strip illustrating the use of a blower to remove dust from the film.

Page 44: Negative print made from a colour transparency. Harsh contrasts are usually preferable in this type of print.

certain that it either includes a drawer for colour filters or has facilities for adding it at any time, or that it accepts a colour head without difficulty.

Unlike certain cine and other photographic equipment, enlargers can be bought second-hand at little risk if the opportunity arises.

Darkroom lighting

Darkroom lights are available in the form of simple bulbs, or as safelights with filters and 15 W clear-glass bulbs. The colours in general use are yellow-green or light brown for enlarging papers and various shades of red for line or process films.

The simple bulb is very cheap, but the advantage of the safelight is that the filter screen is interchangeable.

If you are already toying with the thought of producing colour enlargements one day, buy a darkroom safelight for the 16 × 21 cm filter format, because it accepts the 08 filter for the Agfacolor positive process.

Some lamps are suspended from the ceiling; others are designed as wall fittings or fixed on stands. I consider wall-mounted lamps particularly practical. If you use only one lamp, which is quite feasible, it should be on the wall about 1.2 m (48 in) above the developer dish.

If you want more brightness, set up a second lamp near the enlarger. Your workroom has perhaps a central ceiling lamp. You can conveniently fit it with a yellow-green bulb as a general light source. With coloured light the darkroom can be illuminated comparatively brightly without difficulty. All you have to bear in mind here is that the minimum distance between the lamp and the light-sensitive material should always be about 1 m (40 in).

Photographic papers and sheet film materials should not be exposed even to darkroom illumination longer than absolutely necessary. Do not leave unexposed paper lying about in the open. You must reserve one electrical socket in your darkroom for an ordinary bulb, which should be as bright as possible. (To avoid unpleasant surprises, its switch should not be outside the darkroom). You can inspect your prints thoroughly only in bright light. In yellow-green light they appear much too dark and contrasty.

If you print several enlargements in succession without a few inspections in bright light every now and then, you must be prepared for disappointments. You may switch on the bright light after the paper prints have been in the fixing bath for about 20 seconds.

Masking frames

When I started making my own enlargements, I placed the bromide paper directly on the baseboard. To counteract its tendency to curl I weighted it with heavy coins on all four corners. When I was short of change, I used heavy books along a narrow strip on both short sides of the paper, and trimmed the unexposed margins off after processing.

A masking frame not only has the function of keeping the paper flat; it also is used to align the paper so that the negative is projected truly in the centre of the picture area. Without a masking frame it is quite difficult to place the paper in exactly the right spot on the baseboard. The only safe method is to swing a red filter in the enlarging beam, and switch the enlarger on; you can now see exactly what you have to do.

I gradually became tired of this tedious method, and bought a masking frame for papers up to 18 × 24 cm (8 × 10 in). Whether the purchase of a larger masking frame is worthwhile is a difficult question to answer. The price increases rapidly with its size. Special masking frames, too, are relatively expensive. For horizontal negative projection, there are magnetic metal masking frames, to be fixed on the wall, into which magnetic strips have been let.

Rimless frames use high-quality glass to immobilize the bromide paper, which is exposed without producing the blank rebate to be trimmed off after drying. They are fairly expensive, but offer the advantage of utilizing the paper format fully. I have devised a trick with which I can do this even with paper sizes far larger than the rim of my 18 × 24 cm masking frame. To a large, rigid sheet of glass, Formica, or plywood I apply some contact adhesive spray, and lightly press the paper down on this support. With a little care it can easily be peeled off after exposure. I pressed up to 50 sheets of paper in succession on to my glass plate with

Some enlargers have masks built in to the negative carrier (**top**) so that unwanted light can be masked off when selective enlargements are made. There are various ways of keeping the film flat in an enlarger (**bottom**): a, negative between glass plates. **b**, glass plate on top only. **c**, condenser bears directly on negative. **d**, special condenser with serrated rubber ring.

a single application of contact adhesive spray (the method is suitable also for horizontal projection).

Exposure timers and meters

In the good old days we measured exposures for enlarging by counting one-and-two-and-three-and etc. Apart from the fact that this method was notably lacking in accuracy, we have become lazier and lazier. An exposure timer does the job for us now. It is particularly useful for short exposures, which it controls with perfect accuracy. It is no longer necessary to concentrate on the counting. This is how such a timer works. The enlarger is plugged into the socket of the exposure timer, which in turn is plugged into the mains. The selected exposure time is set on a scale with a rotating knob. Standard instruments include a fine adjustment with a second knob. A button is pressed – and the enlarging lamp lights up for the selected time. For changing the negative and other preparations another button or switch is operated, which turns on the light permanently.

To determine the required exposure time, the trial strip method is as popular as it is time-honoured. It is, however, wasteful of material and especially of time, particularly when many different subjects are to be enlarged in quick succession.

Thus, it was an obvious idea to design exposure meters specially for enlarging. The small selection on the market ranges from inexpensive to expensive models. Some camera exposure meters have attachments that convert them for use in the darkroom. Combinations of exposure meters and timers represent the logical step further; the correct exposure is set in the timing part by the meter. Only a few have been designed so far, so that the selection is not yet very large. They are called automatic timers.

Dishes, bottles, and sundry items

You need four dishes for black-and-white enlarging (as for photogramming); they should accommodate at least 18 × 24 cm (8 × 10 in) paper.

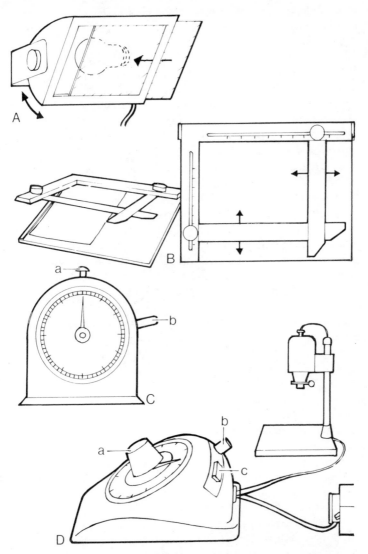

Darkroom accessories: A, Safelight. B, Masking frame. C, Simple timer. a, stop button. b, start lever. D, Enlarger timer. a, setting knob. b, start button. c, lamp on-off switch. The lamp is switched on by the start button and switches off after the interval set has elapsed.

The oblong dishes offered for developing are available with high and with low walls. The high-walled ones are preferable; the developer will spill from the others when they are moved. Furthermore, you will occasionally need larger quantities of liquid, which are sometimes too large for low-walled dishes. Two of these dishes should have lids; if they are not supplied with them, two sheets of plywood of appropriate size will meet the purpose.

The solutions are kept in bottles, a two-litre bottle for the fixing solution, and a 1000 cc (plastic) one for developer. To keep used and unused developer apart it is best to have three 500 cc plastic bottles in reserve. Developer keeps better if it fills the bottle right to the top. If necessary simply squeeze the plastic bottle until the fluid level reaches the neck. Screw the screw top really tight, because squeezed bottles, trying to regain their natural shape, tend to suck in air from the atmosphere if given a chance.

Use two funnels of different colours for pouring the solutions – one for developer and water, the other for fixing solution.

A 1000 cc measure is also required. This should complete your equipment for the time being. I have found a 250 cc and a 25 cc measure very useful.

You need at least two pairs of tongs, preferably a metal one for the developer, and a plastic one for the fixing bath. The tongs for the developer must come into contact only with developer, those for the fixing bath can be used in all solutions except the developer.

Chemicals and bromide papers

We have already discussed the most important chemicals in the context of photogram practice. We shall return to the subject in greater detail in due course. At this point I would merely remind you that you need concentrated developer stock solution to make up 1000 cc of working solution. You also need rapid fixing salt, preferably two packets for 1000 cc each of solution. Glacial acetic acid – added to the intermediate rinse water to make it into a stop bath – is not necessary for the processing of photograms. A 100 cc bottle is sufficient for many stop baths.

So much about chemicals; we must now turn to bromide papers.

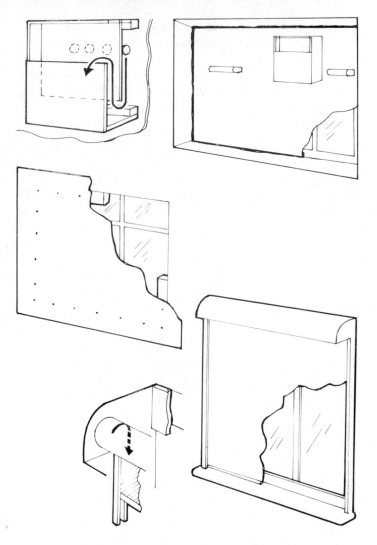

Darkroom blackout and ventilation. **Top**, Air must be admitted only through a double right-angle, which blocks off light. For blackout, a piece of hardboard with hand grips and ventilator can be cut to a push fit. **Middle**, An alternative fitting allows the hardboard to overlap the window. **Bottom**, Special roller blinds running in light-tight channels are efficient and easily operated.

For making photograms you need double-weight postcards of normal gradation. There is no reason why any leftovers should not be used for enlarging. But before you buy new material, it will be useful to have a look at the wide range of papers available. When you buy a packet of paper, you will have to consider seven different features:

Paper format

The range extends from 6.4 \times 6.4 cm (2^5/$_8$ \times 2^5/$_8$ in) to 50 \times 60 cm (20 \times 24 in). Beyond this, even wider paper is offered in rolls. I would suggest as standard formats the already familiar postcard size, especially for the enlarging of negatives taken with simple cameras, and above all 18 \times 24 cm (8 \times 10 in). Experimenting with still larger formats is always rewarding. The larger the enlargement, the more impact has the photograph. Smaller formats can of course always be cut from larger ones.

Paper grade

Six gradations are available, extra-soft, soft, normal, hard, extra-hard, ultra-hard. These terms refer to contrast rendering. A table will be more informative than a long description.

PAPER GRADE AND SUBJECT RENDERING

Subject	Paper grade	Object rendering	Background
Dark grey cat in front of a light grey background	extra-soft soft normal hard extra hard ultra-hard	medium grey dark medium grey light dark grey dark grey almost black black	medium grey light medium grey dark light grey light grey almost white white

From the table it is apparent that hard papers separate the tone values, soft ones compress them. Hard papers are therefore suitable for soft negatives, soft papers for hard (contrasty) negatives.

Landscapes taken under an overcast sky and in a hazy atmosphere are better enlarged on hard paper. The same subject taken in glancing sunlight calls for soft paper. For a start you may find a stock of soft, normal, and hard papers sufficient for your needs. I rarely need extra-soft paper. Ultrahard, however, produces very interesting graphic effects.

Paper tint

The surface can be white, ivory, or cream. The last mentioned tint was meant to imitate skin tones before the advent of colour photography. Personally I find it ugly; in black-and-white photography my only paper tint is white. On an ivory or a cream background a picture appears far less brilliant than on beautiful white paper.

Indeed, almost any toning reduces the picture contrast. The brightness difference between black and yellow can never be as great as that between black and white. Strongly or pastel-tinted papers have recently appeared on the market; some even have a gold or silver background. With suitable subjects – as contrasty as possible – tinted photographic papers can produce attractive effects.

Paper surface

The table on p 54 shows the most important surface textures in current use.

I use glossy paper almost exclusively, but occasionally smooth matt surfaces for large photographs. The range of surfaces available is now tending to shrink and few manufacturers offer the variety of surfaces shown in the table.

When I had to show photographs on television, I naturally used a matt surface. I am sure you will have noticed the horrible reflections when a television camera reproduces glossy photographs.

Drying in a dryer-glazer or on plate glass is recommended for glossy surfaces only. Plastic-coated papers produce a perfect gloss without glazing.

PAPER.SURFACES AND USES

Type of surface	Usual range of applications
Glossy	Album photographs, large photographs (also under glass), photographs for reproduction, object and reportage photographs (fine details are most clearly brought out on glossy paper).
Half-matt smooth	Portraits
Velvet lustre	Portraits, exhibition prints (poorly reflecting)
Smooth matt	Exhibition prints, display, large photographs (without glass) in the living room (no reflections)
Rough, matt de luxe	Exhibition prints, display, large photographs (without glass) in the living room (no reflections)
Silk	Distinguished effect, suitable for fashion pictures, luxury objects
Filigree half matt	Grain—suppressing texture
Filigree glossy	Grain—suppressing texture

Paper weights

Papers are available in single weight and double weight. Postcards and matt surfaces are supplied in double weight only. In all other cases I prefer single weight, for the following reasons:

1 It is cheaper.
2 Double weight papers have to be washed at least twice as long.
3 On single weight it is easier to bring up underexposed detail by breathing on it during development.

Number of sheets

Packings vary, the smaller sizes generally being available in packs of 25 and more and the larger sizes in packs of 10 and 100. The larger quantities are always more economical.

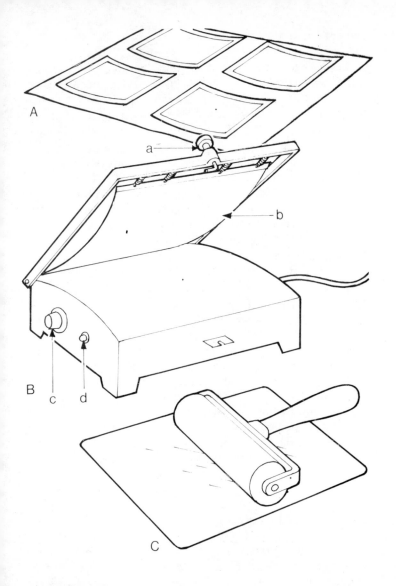

Glazing equipment: A, Glazing sheet. B, Glazing and drying press. a, apron frame lock. b, sprung canvas apron. c, heat control. d, on-off switch. C, Squeegee for flattening prints on glazing plate.

Type of paper

On the one hand, papers differ according to their brand. Materials made by A usually have properties different from those of materials made by B. But the production range of one and the same firm consists of various types. We can disregard special papers for contact printing and for large automatic printers in the context of this book.

Bromide and chlorobromide papers should, however, be of interest to you. Bromide papers are the standard material for enlarging. They are more sensitive to light than chlorobromide papers and less sensitive to variations in processing; but the latter have a more delicate tone range. To begin with at any rate you had better stick to the ordinary bromide papers.

This is all you need to know about papers. There merely remains the question of light-proof storage of the contents of a partly used envelope or box. You could of course leave them in the original container. But having to wrap them up each time you have taken a sheet out quickly becomes tedious. To make matters simpler, some firms offer lightproof paper safes – but at fantastic prices. I have therefore solved the problem in a different way. My enlarger stands on an office desk. This has two advantages. On the one hand it is a rock-steady support for this instrument. On the other hand it offers enough drawers for paper storage, in fact one for each grade. Although I leave the paper in the boxes, I can remove the wrapping paper, which is a nuisance when I want to take out a sheet. Each time before switching on the light I pull up the rollers in front of the drawers. At the end of my work I lock the desk – just to make sure.

Equipment for print drying

A dish is sufficient for the final rinse. It is placed under the tap in the bath tub. The prints need neither be rinsed nor dried in the darkroom itself. All prints with a non-glossy surface, as well as plastic-coated glossy papers can be dried in air. All you need for this is absorbent paper as a support. The emulsion side of the photographic papers must be on top. Glossy papers, too, can be

dried in this manner, but they will then appear half matt. Airdried prints, with the exception of plastic-coated glossy prints, curl strongly and have to be pressed flat afterwards.

Depending on the type, a dryer-glazer cuts down the drying of glossy prints to about 5–15 minutes. If you have decided to buy one, you might as well buy a double sided glazer; if it accepts 30 × 40 cm (12 × 16 in) prints, it will dry four 13 × 18 cm ($^1/_2$-plate) or 12 postcard-size prints at a single stage. Apart from the dryers you need two chromium glazing sheets of suitable size and a roller squeegee.

You can use your glazing sheets for cold glazing, without the machine. To do this press the prints emulsion side downwards on to the glazing sheet with the roller squeegee exactly as for heat-drying. All you need now is patience – for a few hours or a whole night; but this is the only disadvantage. It produces better gloss than heat drying. I have therefore increasingly used the cold method recently.

If two chromium sheets are not enough for the number of prints waiting to be dried and glazed, you can also make use of a wall mirror and the panes of your living room windows for this purpose. If this endangers the domestic peace, a thin, flexible plastic sheet measuring 2 m^2 (10 sq. ft) and with a glossy surface offers an excellent solution for glossy drying. It is less expensive than two chromium sheets. Do not nail it to the wall, because some of the dried prints will not drop off of their own accord. But they will come easily off the sheet if you bend it strongly once or twice.

Water supply and heating

You can use a room without running water as a darkroom, because you need no running water during the enlarging process proper; the situation is, however, improved if you have a tap and sink not too far away.

If you have only cold water in your improvised darkroom, you can use an electric hot plate if you need hot water.

The ideal darkroom, of course, has running hot and cold water laid on.

Warm water is occasionally required to dissolve developer sub-

stances. In addition it is quite useful for regulating the developer temperature. To control this you need a thermometer. Spirit thermometers are to be preferred to mercury ones, which, if they are broken, give off vapours that fog photographic papers. The 20°C mark should be prominent; the temperature of the developer should be between 18 and 25°C, preferably at 20°C.

The correct temperature can be obtained either by heating the entire darkroom or by local heating, especially of the new developing solution.

The room temperature can be raised to 20°C with a fan heater when it is normally lower than that. If, however, the ambient temperature is above 25°C, the solutions have to be cooled.

Fortunately fresh tap water is not quite so warm even during the summer. Cool the developer dish in a water bath – place it in a larger dish with water that is as cool as possible. Slight temperature deviations can be easily corrected with a small bottle of fresh tap water placed in the developer solution. Conversely, you can raise the developer temperature on its own in a warm water bath, or with a bottle of warm water. The temperature must on no account be allowed to sink below 18°C. Electric dish warmers eliminate the splashing about with warm water. Some types strictly maintain a temperature of 20°C.

Some dish warmers accommodate several dishes at a time. Semi-automatic tanks have built-in heaters that can be continuously adjusted between 20 and 30°C.

Locating the mini-darkroom

A separate darkroom of your own is absolutely ideal – but, like all ideals, not always realizable without difficulties. I am averse to the idea of temporarily converting the kitchen into an improvised black-and-white darkroom. Spaghetti in developer sauce is not my favourite, nor am I keen on crossing swords with the rightful occupant. The bathroom, on the other hand, is a serious proposition. The bath tub, for instance, and possibly the wash basin, can be covered with a sheet of plywood. The dishes for the baths will be set up on the improvised "wet bench". If the bathroom is not large enough to accommodate the enlarger, you can set it up

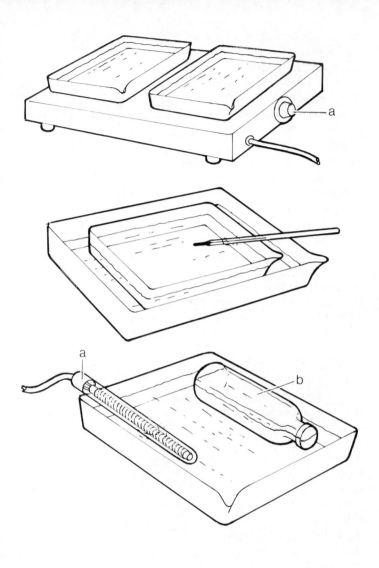

Temperature control: **Top**, Dishwarmer, electrically heated with thermostat setting (**a**). **Middle**, Outer dish with water a degree or two above required processing temperature. **Bottom**, **a**, Electric immersion heater. **b**, floating bottle containing heated water.

on the landing or another room nearby without hesitation. You thus separate the always clean dry work place from the "wet" place, where the "dirty" work is carried out. (Even if they are both in the same room, dry bench and wet bench should always be kept strictly apart). It is obvious that both the rooms involved should be well blacked out and each illuminated adequately by at least one yellow-green bulb.

To meet the needs of the photo enthusiast who is hard up for space the trade has recently introduced complete darkroom out-fits in space-saving kits.

Those who are not unduly pressed for space might be able to set up a permanent darkroom, if not in the flat or house, then in the corner of a garden shed or garage, or even in the cellar (if they are lucky enough to have one). Perhaps a minor conversion will do the trick. Attics unfortunately are mostly very remote from wa-ter taps and sinks. To carry the necessary water and the used so-lutions up and down stairs or a ladder requires some enthusiasm. Cellars are on the whole more suitable. Water is readily acces-sible; furthermore, the recent conversion of heating systems from solid to other fuels has freed a lot of space formerly taken up by coal.

If you do have a room available, here is the basic scheme that has been found best for setting up a darkroom.

The enlarger is placed on a table (office desk) along the narrow side of the room. Along the wall to the right another table or shelf is set up as an additional work place. This accommodates, from left to right, the dishes for the developer, the intermediate rinse (stop bath), the fixing bath, and the water for the collection of the processed prints. This is how I set up my own darkroom. I find it very convenient to be able to work from left to right. Furthermore, I thus keep the dry and the wet places apart.

The working top of my wet bench along the wall to the right of the enlarger is 93 cm (3ft 1in) high. I prefer to process my material standing up. The enlarger I operate sitting down.

Concerning the electrical aspect: do not improvise with exten-sion cables. Do not interfere with the mains supply, especially in the bathroom or cellar. A qualified electrician should instal the connections according to the safety regulations and ensure that sockets, cables, and electrical instruments are properly earthed.

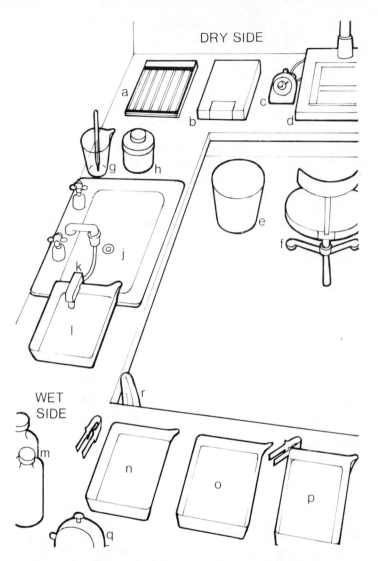

DRY SIDE

WET SIDE

Darkroom layout: **a**, contact printing frame. **b**, printing paper. **c**, enlarger timer. **d**, enlarger. **e**, waste bin. **f**, movable chair. **g**, measure and thermometer. **h**, developing tank. **j**, sink. **k**, print washer. **l**, print washing dish. **m**, storage bottles. **n**, **o**, **p**, processing dishes. **q**, timer. **r**, rag for spilt solutions.

Do not forget that you are handling electrical equipment and liquids at the same time.

Machine-printing processes

There is an alternative to the rather long-winded procedure of developing, fixing, washing, etc. of the standard bromide print. Special papers are available in which the emulsion incorporates a developing agent – generally hydroquinone. These papers are exposed in the normal way but are then fed into a machine containing two trays of solutions and a motor-driven system of rollers similar to that of the wet-solution office copying machines.

The first solution is an activator – basically caustic soda – which, in conjunction with the hydroquinone in the paper, forms a very rapid working developer, bringing up the picture in full detail as the paper passes through the rollers. The bottom roller picks up activator and applies it thinly to the paper, which does not actually enter the solution.

The second solution is a stabilizer – basically ammonium thiocyanate as a rule, but with many additives. The print may actually pass through the stabiliser solution but is then damp-dried by a final pair of rollers.

The main advantage of this process is, of course, speed. The exposed printing paper is taken straight from the enlarger to the machine and a finished print emerges in seconds. Some space is saved, too, because the machine occupies less room than three or four dishes of the size required for the machine's maximum print size.

There are other advantages. The stabilized print does not need to be washed. In fact, it must not be washed. If it is, it becomes light-sensitive again. Development is always uniform, so that identically exposed prints are identical after processing. Stabilized prints last almost indefinitely if kept away from bright light but will begin to fade after a few months' exposure to light. They can, however, be fixed in the conventional manner at any time before they begin to deteriorate and are then as permanent as conventional bromide prints.

The disadvantages are that the number of paper grades and sur-

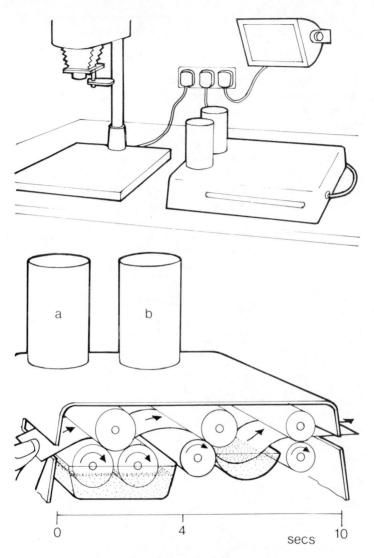

The processing machine replaces separate dishes of solution. After exposure on the enlarger, the paper goes straight to the machine and emerges 10 seconds later as a stabilized damp dry print. Operation of the machine (bottom): a, activator solution. b, stabiliser solution.

faces is more restricted than for normal paper and the stabilization papers are slightly more expensive. No after work involving liquids (not even glazing) can be carried out on a stabilized print unless it is first conventionally fixed.

Holding back and printing up, etc. can, of course, be carried out in the normal way by manipulation of the enlarger lamp beam (see p 126).

These disadvantages are minor, however, and are largely offset by the fact that the machine is always ready for operation. Even a single enlargement can be produced at any time. Activator and stabilizer become exhausted through use only, they do not spontaneously decompose like made-up developer.

No solutions need be prepared. Activator and stabilizer are ready for use.

These advantages speak for themselves. Frankly, what interests me most is that even those whom lack of space has so far prevented from taking up enlarging now have a real opportunity.

Making
the
Enlargement

This chapter deals with the old-established principles of black-and-white enlarging from beginning to end.

I shall start with the list of all the steps in enlarging; in the following paragraphs I shall explain them in great detail.

Processing steps in black-and-white enlarging

1 Making up the solutions: Prepare developer solution. Place a dish of water (if desired with a little glacial acetic acid) next to it. This is followed by a dish containing fixing solution. Another water bath is in the last dish. The temperature of the developer should be about 20°C.

2 Darkroom illumination: The white light is switched off, and the yellow-green darkroom safelight switched on.

3 Insertion of negative: The negative is well dusted with a brush or blow bulb and inserted in the carrier emulsion (matt) side downwards.

4 Composing and focusing: The negative is projected on to the masking frame or the baseboard (on a sheet of white paper as focusing aid). Arrange the desired picture area at the desired enlarging scale. If the enlarger is of the manual focusing type, match focusing and enlarging scale.

5 Trial exposure: First make a rough trial exposure on a piece of normal paper of reasonable size. Successively expose four strips, say for 3, 6, 9 and 12 sec. Develop, rinse, and fix for 20 sec as described under 7–9. Make sure no fresh bromide paper is lying about openly. Switch on the white light and inspect the trial strip. If the exposure has been wildly wrong, or if you want to change the type of paper, you must expose a second trial strip.

6 Exposure of the paper: Expose the paper according to the result of the trial exposure.

7 Development of the bromide paper: The paper is immersed in the developer emulsion side up, pushed to the bottom of the dish, turned over, and turned back again. When it is fully covered by developer, the dish must be very gently rocked. Development of the picture is complete after about $1\frac{1}{2}$ to 2 minutes, depending on the type of developer.

8 Intermediate rinse or stop bath: Take up the print by a corner

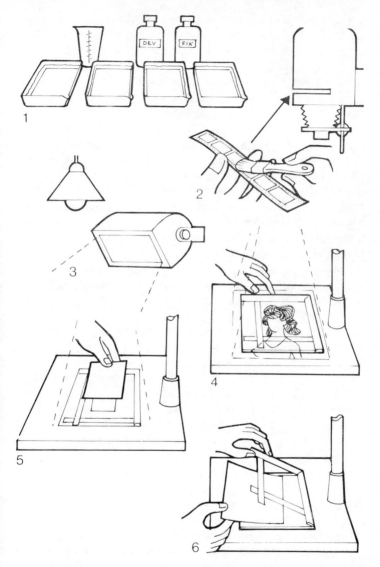

Enlarging procedure: 1, Set out solutions. 2, Dust and insert negative. 3, Turn out white light. 4, Focus and compose picture. 5, Make and process test strip to determine exposure. 6, Insert sheet of printing paper in masking frame and expose.

with the pair of metal tongs and allow it to drain for 15 seconds. Drop it in the stop bath, grip it with the plastic tongs and immerse it for a few seconds. Remove it and again allow it to drain for 15 seconds. (Coated papers are simply given a short rinse in water).

9 Fixing: Immerse the print in the fixing bath for at least 2–3 minutes (rapid fixing bath), agitating it a few times with the tongs. After 20 seconds the print may be inspected in white light.

10 Wash: After fixation the print is transferred to a water bath, in which all the enlargements are collected. After the end of processing, the lot is passed on to the final wash if possible in running water; single-weight papers require at least 30 minutes', double weight ones at least 90 minutes' washing.

11 Drying: Before they are dried, the prints can be immersed in a wetting agent bath for 30 sec – 1 min. Squeegee the prints on a Formica sheet or glazing sheet for the dryer-glazer; make sure to expel all air bubbles. Prints to be glazed later should be provisionally air dried. They should not remain in water overnight. Plastic-coated papers can be laid out to dry, emulsion side up, on old paper immediately after the rinse or strung up on a washing line with laundry pegs.

12 Trimming: The white margins have to be trimmed off the prints; this is best done with a trimmer. For very large formats a ruler and pen knife must be used.

13 Clearing up afterwards: Pour the developer into a plastic bottle through a funnel; close the bottle airtight. The fixing bath can remain in the dish, which should be covered with a lid. Discard the stop bath and the final water bath.

14 Spotting: Spot white dots with a sable brush and black retouching dye.

Preparing and storing the solutions

All my developer chemicals are ready-mixed when bought. I do not waste my time making up my own formulae. I am not ambitious enough to go one better than industrial research in photochemistry; my main interest lies in pictorial composition within the possibilities of the enlarging process. Developer powder merely has to be dissolved and thoroughly stirred in water.

Fishermen of Orebic, Yugoslavia. This is an overexposed print on hard paper making the heads stand out in profile against the light background (see following pages).

From the same negative of the fishermen of Orebic this correctly exposed print on normal paper has less impact than the overexposed print.
Opposite: The top four prints were all made on extra-hard paper with progressively increasing exposures. The other two were made on soft paper. The normally exposed print on the left is flat but the other, heavily exposed, simulates a night effect.

Another variation of the fishermen of Orebic, provided by a double solarisation process. *Opposite:* The wavy screen effect at *top left* is not very effective because the paper used was too soft. The screen foil print below it on a harder paper is more satisfactory. *Top right* is a contact print from the print in the same position on page 70. *Centre right* is a contact print from the print next to it. *Bottom left* is a solarisation effect while next to it is a print from a contour film copy.

In-register negative-positive screen com-
binations from density separations (for
isohelie compositions).
Top: Triple-exposure with an unscreened
positive and two combined negative
separations through differently arranged
screen foils.
Right: Double exposure with a negative-
positive combination and a screened
negative.

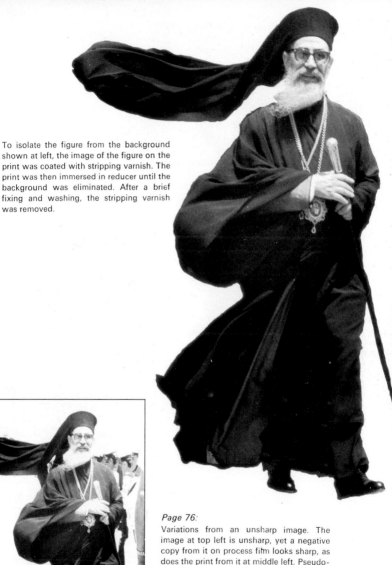

To isolate the figure from the background shown at left, the image of the figure on the print was coated with stripping varnish. The print was then immersed in reducer until the background was eliminated. After a brief fixing and washing, the stripping varnish was removed.

Page 76:
Variations from an unsharp image. The image at top left is unsharp, yet a negative copy from it on process film looks sharp, as does the print from it at middle left. Pseudo-solarisation (*middle right*) on process film produces the typical sharp outline so that the print from it at bottom left also gives an impression of sharpness. The final print is an offset combination of top right and centre left.

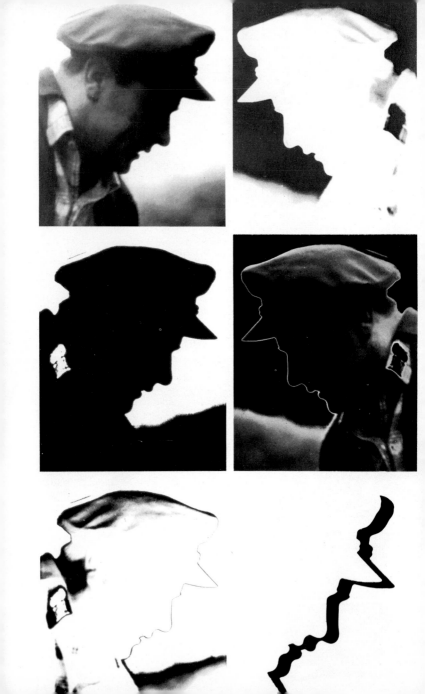

Important: a distinction must be made between negative developers for films and paper developers. Concentrated stock solutions of paper developers are particularly convenient to use. Pour the entire contents of the bottle into the measure, and make them up to 1000 cc by adding water at 20°C. Stir well, and your developer is ready for use.

A little water more or less makes little difference. Some developers stand considerably weaker and stronger dilution, which of course influences the character of the development. In the interests of brevity, the relevant information on such a developer is tabulated below:

EFFECT OF DILUTING DEVELOPER

	Dilution rate	Make up contents of bottles*	Property of developer	Developing time (min)	Keeping qualities of the solution	Uses
Stock solution	1 + 3	500 cc	very contrasty	about 1	Unused in fully airtight bottle 6 months. Keep in part quantities	Brilliant graphic effects
Standard solution	1 + 7	1000 cc	normal	about 1½	used solution 1 week, unused solution in full bottle 2–3 weeks	normal use
Economy dilution	1 + 11	1.5:1	slightly softer		1 day	processing of a large
Economy dilution	1 + 15	2:1	slightly softer		1 day	number of large formats within a short time

* Based on standard quantities for 1000 cc.

Larger formats are the easier to process the more liquid is available. The use of the economy dilution is therefore recommended. If you need the contrastiest possible results with a graphic effect, use the 1 + 3 dilution.

In addition, the stock solution solves a much more important problem. It allows you to economize in your developer especially

when you need only part quantities. After all, 1000 cc developer is enough for more than 4 sq. m (5 sq. yd) bromide paper, about 100 18 × 24 cm (slightly fewer 8 × 10 in) sheets or 280 postcards. Whoever uses up such a lot of paper at a time?

But used developer keeps for no longer than one week even in a full bottle (economy-diluted solutions must be used up immediately). Undiluted part-quantities of the concentrated stock solution, too, should not be stored. This is the way out:

The concentrated solution is first diluted with water to make 500 cc. Pour the quantity of developer you really need into the dish. Pour the rest into the 500 cc bottles. If necessary squeeze them to raise the level to the top. Only if all the air has been expelled from the bottle will the stock solution keep for six months.

The amount of liquid you need may be very small. After all, it must be diluted at least with twice, at most with four times the volume of water. Stock- and standard dilutions may remain in the dish if they are used up within the next two days. Here, too, exclusion of air is an advantage.

The cheapest paper developers come in powder form, which does not mean that all chemicals supplied in this form are necessarily cheap.

Our practical stock solution procedure can be used also with some types of powder. Sometimes this is pointed out in the instructions for their use. Otherwise you have to proceed by trial and error. Whether or not making up with just under 500 cc water promises success must become obvious already while you stir the solution. These packets of chemicals usually consist of 2 bags – part A and part B. For normal preparation part A is first dissolved completely in 650 – 750 cc water at a temperature between 30 and 40° C. Only then is the larger part B added. Finally, the whole is made up to 1000 cc with cold water. Sometimes the two parts must be dissolved separately, and the two solutions poured together.

If, however, you take only half the quantity of water certain developer substances may not dissolve completely.

Developers made up from concentrated stock solutions are ready for immediate use. Developers prepared from powders, on the other hand, ought to be allowed to stand for 24 hours, to mix thoroughly. Usually this need not be taken literally. I have quite

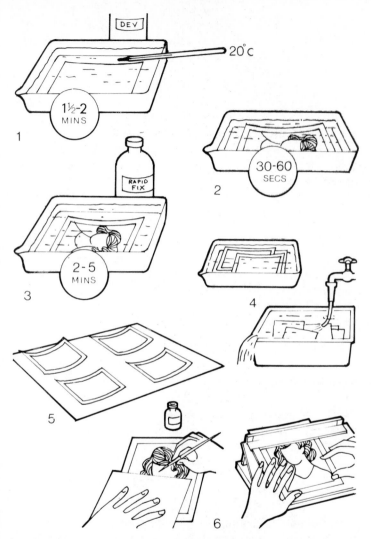

Processing the enlargement: 1, Place print in developer for 1½–2 minutes. 2, Transfer to stop bath for 30 seconds. 3, Transfer to fixing solution for 2–5 minutes (or more if rapid fixer is not used). 4, Transfer to water bath to await washing. 5, After wash, lay on clean cloth or blotting paper to dry. 6, Spot print and trim to required final size.

often used such types of developer immediately after making it up. But if high picture quality is essential, for instance for exhibition prints, developers in powder form should really be made up 24 hours before.

Obviously the question arises what – apart from the price – developers in powder form are good for. After all, concentrated stock solutions make enlarging so much easier. Yet, the choice of developers in powder form is so much wider than that of solutions. There are more types, and each type produces its own special results. One of them, for instance, results in a cold black tending towards blue instead of the usual neutral black print tone. Another one offers the warm, slightly brown-black tone so much favoured by many photographers for large-format exhibition prints.

Some developers produce soft, others more contrasty photographs. Every developer, by the way, becomes progressively more "contrasty" after the first few prints but once it is completely exhausted, the prints will be completely flat.

Medium-hard water fresh from the tap is most suitable for making up developers. Dirty water shoud be filtered. Water containing too much lime or chlorine should be boiled.

Rinse and stop bath

Next to the developer comes the dish for the intermediate rinse, either plain water, or a weak solution of glacial acetic acid.

The stop bath substances are sold in 100 cc bottles and should be added to the water at a ratio of 1:40 or 1:20 according to the instructions for their use. The solution cannot be stored. The stop bath has two tasks:

1 To prevent the continued action of the developer taken up by the paper.
2 To prevent the contamination of the fixing bath by active developer.

Some photographers are not very keen on stop baths. If an ordinary fixing bath is used, it is by no means essential. Before go-

ing into a rapid fixing bath, however, the prints should preferably pass through a stop bath.

Fixers and fixing

The fixing salt is dissolved in lukewarm water. This should not be done in the darkroom which must be absolutely free from fixing salt dust. Some fixers, however, come in concentrated solutions and, as with developers, they are much easier to handle.

The same chemicals are used for fixing films and paper but the paper fixer is the more dilute. Paper and films or plates should never be fixed in the same solution.

If you exhaust this very cheap bath too much you will save precisely in the wrong place. The appearance of the solution does not reveal whether it is still fresh enough or exhausted. One litre of fixing solution processes only half the number of prints as one litre of developer. I therefore always make up two litres of fixing bath for every one litre of developer. When the developer is exhausted I also pour the fixing bath away. Both fresh and partly used fixing bath keeps practically indefinitely. You can store it either in a two-litre bottle or in a dish covered with a lid to prevent evaporation. The temperature of the bath is not critical, but below 18°C it loses some of its energy, and the prints, to make up for this, must be fixed a little longer.

Dust and Newton's Rings

The negative for your first enlargement should be one that appeals to you.

Many negatives do not keep what they promise at first glance; others reveal hidden beauty only after you have carefully studied them.

To do this it is important to print a contact sheet of your film as described on p 24.

Having found a particularly attractive negative, you now must take up the fight against your worst enemy – dust – even before you insert the negative in the carrier. The most infuriating feature

of dust is that it is so effectively camouflaged on the negative and the negative carrier that it can hardly be seen.

But the finished print mercilessly reveals its presence in the form of white dots scattered all over it. Fortunately a method exists of discovering dust before it has a chance to become a nuisance: hold the negative directly below the stopped-down enlarging lens obliquely into the light beam of the enlarger; the dust particles begin to sparkle. To wipe them away with a piece of cloth would charge the film up electrically, converting it into a most effective magnet for more dust. Moreover, cloth occasionally leaves scratches on the negative.

Before I go further into this annoying subject, a survey of all the reliable and less reliable methods of dust prevention will put you in the picture.

METHODS OF DUST PREVENTION

Cleaning aid	Disadvantage	Advantage
Dry, washed handkerchief	Danger of scratches, negative attracts more dust	
Handkerchief dipped in wetting agent and dried	Danger of scratches	Counteracts static charges
Handkerchief dipped in Tetenal film polish and dried	Danger of scratches and formation of Newton's rings	
Anti-static cloth	Ditto	
Slightly damp, soft piece of chamois leather	Danger of scratches	Sometimes necessary to remove drying marks quickly. Best to wipe only the back, not the emulsion side
Damp film polish	Danger of scratches from cloth. Formation of Newton s Rings. Never treat films immediately before enlarging	Static charge is counteracted. Suitable method of roughly cleaning dirty negatives 24 hours before enlarging

Cleaning aid	Disadvantage	Advantage
Dust or sable brush	Does not remove resistant, firmly lodged dust particles.	Weak or no static charge. No scratches
Blower (rubber ball); especially useful dust brush with rubber ball: brush head detachable	Ditto	Static charge and scratches avoided
Blowing dust away by mouth	Ditto	Scratches avoided. Moisture counteracts static charges
Tip of the finger picks off dust	The tip of the finger must be dry and free from dust: otherwise more dust will be on the negative than before	Best method of removing individual dust particles resisting the brush and the blower
Rinse piece of film again in water and wetting agent	Film must be allowed to dry	Resistant dust particles and drying marks are removed. No scratches

Not only the film, but also the film guide is sometimes dusty. Especially the glass stages must be treated with brush and rubber ball. Resistant dirt is removed with methylated spirit. Unfortunately negative stages with glass pressure plates breed Newton's Rings. These peculiar structures are formed by microscopically thin layers of air between the smooth film back and the top glass of the negative carrier or the underside of the condenser, depending on enlarger design. On colour transparencies such air wedges sometimes occur even between the coverglass and the emulsion side.

Moisture encourages this nuisance. Cleaning with anti-static agents therefore always requires some care. Moreover, Newton's Rings are difficult to see in the projected image of the negative. They sometimes disappear as soon as the position of the negative in the negative stage is minutely changed. In persistent cases the

negatives are individually mounted in cardboard frames like slides; this prevents contact between the negative and the glass pressure plates on both sides and eliminates the risk of Newton's Rings. It is often enough to wedge a thin paper mask between the back of the negative and the condenser.

Scratched negatives can be pulled through an antiscratch solution, which fills the scratches so that they become less noticeable. It is useful to try it on a piece of waste film first.

Original negatives should be inserted in the negative carrier emulsion side downward to produce right-way-round enlargements.

Enlarging scales and sharpness

When you rotate the lens to refocus you alter the enlarging scale. When you move the enlarger head up or down to obtain a different enlarging scale you must refocus. If you are the lucky owner of an autofocusing enlarger you may forget all about focusing between about $2 \times$ and $10 \times$ enlargement of your 35 mm negatives.

For manual focusing place a finished photograph in the masking frame or on the baseboard with the back facing upwards. The white area serves me as a projection screen, as it were.

Sharpness can be assessed very effectively when negatives on fast films are highly enlarged, because the grain will become noticeable. At very weakly enlarged or even reduced (transparencies) projected negatives I look through a magnifier – a reading glass. One of the relatively cheap focusing devices is, however, preferable. It is simply set up in the picture area. A portion of the negative appears on a small ground glass screen or can be inspected through a special magnifier. Without any focusing aid it must be regarded as a pure accident when a flat negative on a slow film produces a really sharp print. In such difficult cases I temporarily replace the negative with one that is more suitable – with a test negative, so to speak.

For once you have determined the sharpness for a certain enlarging scale, you can exchange the negative in the negative stage at will, without even looking at it. You need to worry about

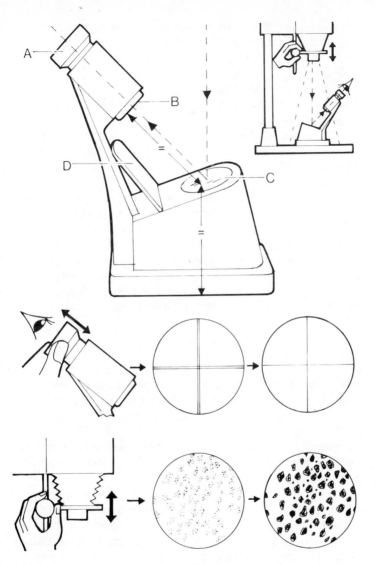

Focusing magnifier: Image-forming rays are reflected from the mirror C to a glass with cross hairs at B. The cross hairs enable the eyepiece A to be focused on the aerial image B. Powerful magnification shows distinct grain pattern when image is sharp. The mirror is covered by flap D when not in use.

the focus again only when you adjust the enlarger head, or when you want to enlarge a negative wrong way round, for which it has to be inserted in the negative stage emulsion side up. This wrong-way-round copying can, by the way, quite considerably alter the effect of a picture.

The choice of picture area affects the impression of the final enlargement even more radically. It is not necessary either to utilize the entire negative or to adhere slavishly to its side ratio. Extremely narrow vertical or horizontal pictures have a special appeal. Nine out of ten square negatives are trimmed to produce a vertical or horizontal format.

Stop down the enlarging lens considerably before the exposure. I would recommend f11..(For focusing, use full aperture.)

You are urgently advised as a rule always to use the same working stop. If you note the exposure time on the back of a particularly successful enlargement you will find it easy to reproduce it exactly at the first attempt at any time. If you have no masking frame, you can check the position of the bromide paper on the baseboard in the red-filtered light of the enlarger.

Making test strips

Modern bromide papers have the same sensitivity irrespective of their grade. The only exception is ultra-hard, which requires double the exposure time. (Until recently, the softer the paper, the faster it was).

In practice this raises the question whether you can change from one grade to another between extra-soft and extra hard without the need to repeat your exposure test.

Well, if a print that has had the right exposure is too hard for your liking there is no reason why you should not give the same exposure for any softer paper. In the opposite direction, from soft to hard, occasionally slight corrections may be necessary. Harder papers do react more strongly to minor deviations in the exposure, which softer paper will readily accept.

If you want to expose a test strip, but are undecided whether your subject calls for soft or normal paper, it is therefore best always to start with the harder paper.

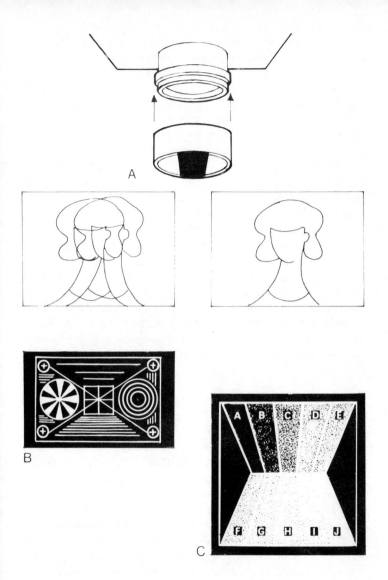

Enlarger aids: A, Simple construction to provide split-image focus-
ing. B, Special focusing negative for checking lens performance
and copying work. C, Exposure calculator. A single exposure
through graduated densities gives a mechanical test strip.

This is how you determine the correct exposure if you have no measuring device. Cut a reasonably wide strip off a sheet of normal paper. The wider the strip the better it can be assessed. If you are totally inexperienced in enlarging, use it, to begin with, for a rough test. After some practice you will be able to manage with a single, fine test. Place the paper strip on the projection area and expose it in steps of 5, 10, 15, and 20 sec. (This applies to large enlargements. For small sizes, postcards and smaller, expose for 2, 4, 6, and 8 sec.).

The best method is to cover three-quarters of the strip with cardboard and expose for five seconds. Then uncover one quarter (one half of the strip still covered) and expose for a further five seconds. Uncover another quarter (one quarter of the strip still covered) and expose for a further five seconds. Finally expose the entire strip for another five seconds. Process the strip as usual, switch on the white light after 20 sec fixing. If one of the fields is correctly exposed, say at 10 sec, obviously this will be the exposure time for the enlargement. If some fields are too light, others too dark, a more narrowly graded esposure test will be useful, e. g. if the 5 sec test field is too bright, the 10 sec one too dark, expose another trial strip for 6, 7, 8, and 9 sec.

Between extra-soft and ultra-hard

In the past, questions of contrast control were very difficult to grasp for the photographic beginner. Today this has radically changed, largely owing to the contrast control on our television sets.

Imagine a brunette on your television screen. If you turn the contrast up, the hair will become a black blob, the face a white patch. If you turn it down, the picture will be without clear whites, without decent blacks. All you see is an ugly grey mess. The same happens to a sunlit, shadow-casting marble statue on the television screen. Set too contrasty, the sunlit portions lack all detail, which has become submerged in white. The shadow, on the other hand, has become impenetrably black. The opposite extreme results in a flat picture, which has completely lost its original sunny atmosphere.

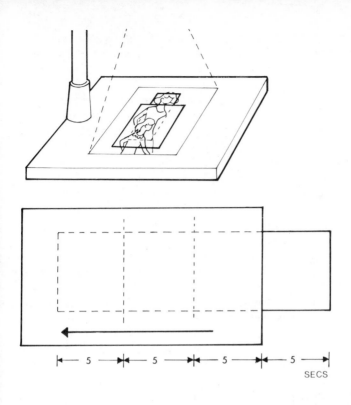

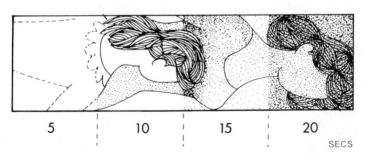

|← 5 →|← 5 →|← 5 →|← 5 →|
SECS

5 10 15 20
SECS

Making a test strip: A strip of paper is exposed piece by piece to
give a series of exposures of varying durations. After processing,
the correct exposure is chosen for the final print.

89

In the darkroom the six paper grades take the place of the contrast control of the television set. What happens in principle is that weaknesses of the negatives are compensated. These weaknesses can have various causes some of which we shall discuss below. Ideally, a bone-hard negative enlarged on extra-soft, and a soft negative enlarged on extra-hard paper should produce an (almost) as harmoniously graded picture as a normal negative on normal paper. But the character of a negative is not always obvious: who would guess that a very thin, translucent film can be as flat as a dense, almost opaque one? Both must be enlarged on extra-hard or ultra-hard paper – but at vastly differing exposure times.

In enlarging we aim at a balanced picture. What does "balanced" mean? In times past, photographers were quite definite, if a little one-sided, about it; choice of paper grade, exposure, and development were to produce an enlargement which had a rich scale of delicately graded grey values between black and white. A good enlargement must therefore contain almost black tone values, almost white tone values, and as many intermediate values as possible.

I need not emphasize that our present-day ideas of a well-balanced picture are entirely different. We accept graphic photographs – pure black on pure white – as readily as those consisting of only a few delicate grey tones. It can nevertheless do no harm to try, every now and again, to realize the traditional approach of the photographic craftsman, because it is quite a good method of gaining an understanding of the principles of enlarging.

Different pictures from a single negative

Let us put the "classical" idea of the "balanced" print in its proper perspective: if the demand of careful tone gradation were to be carried to its logical conclusion, only one correct enlargement could be made of any one negative. In actual fact, you can create two or more pictures of completely different impact yet equally interesting from many a negative. Whether a negative is "fertile" or not depends on its exposure, the lighting contrast, and above all on the subject. Architecture and rocks photographed in con-

trasty lighting for instance can be normally reproduced in the darkroom, on the other hand, they can also be converted into night pictures. All you have to do to produce this effect is strongly overexpose normal, soft, or extra-soft paper.

A typical night effect is produced without fail by suitably treated infra-red negatives. Simple red – and orange – filtered negatives, too, can be used for this purpose. In favourable conditions – contre jour or glancing light – even unfiltered negatives will produce this result.

On the other hand, vigorous graphic effects, such as silhouettes, are obtained when a normal to contrasty negative that should really be printed on normal paper is enlarged on ultra-hard paper. The table on p 92 lists a few methods of manipulating the character of a picture by means of exposure time and the various paper grades.

I must, however, point out that not every negative lends itself to such treatment. Yet even failed experiments of this kind have a certain value. They add to the fund of your experience.

I always write exposure and paper grade on the back of the enlargement with a soft pencil after such darkroom experiments to obtain a basis for effective evaluation.

We can start from the assumption that hard papers are usually better suited for experiments than soft ones (exception night effect). The photographers of the Old School, it is true, did not think much of excessively contrasty enlargements. In one point – I must admit – they were quite right. After all, the tone values of a picture are reduced when it is printed on paper that is too hard. This means in the last resort that a picture processed in the darkroom for graphic effect has less information content than the enlargement with the correct tone values of the same subject.

For example, a negative shows Doric columns in front of a white sky covered with dense cloud. The honest-to-goodness, normal, slightly pedestrian enlargement offers all the details of the subject, even the flutes on the drums of the columns. On another print, greatly underexposed- and more striking – the columns appear as dark silhouettes. The flutes are drowned in black, gone, invisible. The information content of the picture has therefore been reduced. But we have reached a stage when it is no longer necessary for a picture to have the greatest possible information

EXPOSURE AND PAPER GRADE VARIATIONS

Darkroom procedures	Negative	Effect
Normal exposure. Paper grade matched with the negative character	Any	Delicate grey-value gradation from almost black to almost white
Paper too soft, very generous exposure	Negative taken in strong light-shade contrast (contrejour, glancing light)	Night effect (pictures of suitable subjects taken in daytime)
Paper too hard, very generous exposure	Negative taken in diffuse light with normal exposure	Silhouette effect. Subject appears black, background in half-tone. Pure black-and-white contrasts can be obtained if the enlargement is copied
Paper too hard. Normal to generous exposure	Contrasty negatives	Graphic effect. Enhancement of effect possible also through copy negative or reproduction of the enlargement
Paper too hard. Short exposure	Dense (strongly over exposed) negative taken in diffuse light	High-key effect. A few light grey tones and white fill the picture area. Black present in small dots

content; what is decisive is that the information available can be processed by the viewer in the shortest possible time.

In an age in which we are surrounded by a sea of pictures we simply have no time to enjoy the details of one picture for hours. The main requirement is quickly to absorb the picture content and to store it in the memory. Too much information in the picture, however, obstructs this process of absorption.

It is therefore quite reasonable – indeed often even absolutely necessary – to get rid of the surplus information in a photograph

by means of darkroom manipulations. The detail-less outlines of the columns of the temple can have a much more striking effect than the softer rendering with full detail but little impact. In other words: contrasty enlarging and short exposure produce a poster effect.

With another darkroom manipulation, however, the photographer can also evoke a certain atmosphere in a picture. It is true that this supersedes the objective information about the subject; but at the same time it adds some subjective information on it; it expresses something about the emotions the object has aroused in the photographer.

Loss of grey values, then, means a loss in information quantity, but a gain in information quality. This is the vital impulse of the creative approach in graphics and photo-graphics.

It is, however, not always necessary to compress the tonal scale at the expense of the light and in favour of the dark tones. The opposite effect is provided by the high-key method. This is based on strongly overexposed negatives of softly lit (bounce flash) subjects – mostly portraits. The enlargement must have a short exposure so that the tone range is compressed into a few bright hues. Only minute black dots and lines (eyelashes, pupils) should enliven the white and delicately grey picture area.

Another method that leads to delicate high-key pictures; strongly overexpose soft bromide paper to a suitable negative and briefly develop the paper in film developer. Remove the print before the tones become too dark.

Papers in the developer

The admissible latitude for developer temperatures extends from 18 to 25°C. The higher the temperature, the faster the development of the prints. But do make an effort to maintain the standard temperature of 20°C reasonably accurately.

In the past, prints were always developed by inspection in the fairly bright yellow-green safelight. A correctly exposed print comes up after about 15–20 sec in the developer. The black detail rapidly builds up on the white area of the paper. After some time this process seems to be completed. A little time was allowed for

consolidation before the print was removed from the developer. This method is not reliable enough. Simply set your darkroom timer at a certain time; as soon as it rings, transfer your prints to the intermediate rinse (stop bath). The second hand of an alarm clock is also clearly visible in yellow-green light.

If you ask me for the optimum developing time for enlargements, I shall be at a loss for an answer. It depends very much on the make of bromide paper and of the developer. At 20°C it varies between 1½ and 3 minutes. Since a slightly extended developing time does not do the print any harm, many photographers always develop for 3 minutes. This works quite well, but I see no reason why one should waste an extra minute when the process is complete after 2 minutes, which applies to types of paper used today.

I tested my own material as follows: by means of a trial strip I determined the best exposure time for 3 minutes' development. I then gave the same exposure to four sheets of paper successively. All four sheets went into the developer together but were removed one at a time after 1½, 2, 2½ and 3 minutes. I had noted each developing time on the back of the sheets in advance.

Here is the result: there was no difference between the 2-minute and the 3-minute print for any given paper grade. Since then my darkroom clock rings regularly two minutes after the start of the development.

You will, I am sure, occasionally find that no sooner have you dipped the paper into the developer than the first traces of the image appear. This is a sure sign of fairly hefty overexposure. You may prematurely break off development, but the result will be a rather flat print. This, like the forced development of an underexposed enlargement, is far from ideal.

If you exceed the rated developing time considerably, you will merely fog present-day papers. There is not much point in doing this. True, I, too, have quickly soaked a hopelessly underexposed print in hot water, and returned it to the developer. But I cannot in all honesty claim that the result was particularly brilliant. It makes little difference whether you throw an underexposed print away or ruin it in hot water.

The situation is more hopeful when the print had generally received the right exposure, but some detail fails to come up sufficiently.

94

Fastidious photographers lift the print from the developer with a pair of tongs, and breathe on the offending portions. Reckless ones grab it with both hands in the solution, take it out and rub the bright spot with their index finger; I have not yet found a description of darkroom practice that does not rigidly condemn this method. Certainly it is a messy business – even if it is very successful. You should practise it only if you can immediately wash your hands thoroughly – if possible in warm water – and dry them. The danger that with your dripping fingers you will contaminate your whole darkroom with developer splashes is very real. The method of rubbing is therefore a very bad one for saving a print, but a method nevertheless; use it only when everything else fails. If you are allergic to developer, keep your hands away from it, and wear rubber gloves. The tongs used for the developer should never stray far from it; not even into the intermediate rinse, which is already the preserve of the fixing tongs (these, conversely, must never come into contact with developer). Metal tongs should be used for the developer; they are easier to handle than plastic ones but they do occasionally leave black lines on the surface of chlorobromide paper or indeed, on any paper without a super coating or anti-stress coating.

Extensive, annoying patches on an enlargement are probably the result of uneven development. The only method of preventing them is adequate agitation of the solution during development. Push the exposed paper, emulsion side up, obliquely below the surface of the developer. Press it to the bottom of the dish with the tongs, making sure that the entire surface is covered with developer; "islands" will remain white on the finished print. Again with the tongs, turn the paper round, so that the emulsion side faces downwards, and repeatedly push it to the bottom of the dish. When you turn it round again, the first traces of the image should have begun to appear. Now raise one side of the dish gently, producing a wave of developer that evenly sweeps across the print; repeat this several times until the darkroom timer rings. Grip a corner of the print with the tongs, raise it, and count slowly up to 15, to allow most of the developer to drain off; too much of it carried over into other baths would contaminate them. Drop the print into the intermediate rinse (stop bath).

How many prints can be processed together? It depends on the

size of the developing dish, the volume of developer in it, and the size of the papers. Do not place more than six sheets at a time in the developer. In fact, it is best to process only one print at a time.

Almost as soon as it is in the fixing bath you may judge it in white light, and decide whether to make another enlargement of the same negative at a corrected exposure time or to pass on to another negative.

Intermediate rinse and fixing

Plain water is quite adequate for the intermediate rinse; the prints should be washed in it for 30–60 sec. Unfortunately it is unavoidable that gradually a comparatively large amount of developer is carried over into the intermediate bath converting it slowly into a very dilute developer solution. In a long printing session, the intermediate rinse should therefore be renewed from time to time. Alternatively, you can use a stop bath instead of the plain water bath. Ready-packed stop bath chemicals are stocked by photographic dealers. They are added to the water in suitable quantities. The prints should spend about 30 seconds in the stop bath. Before their transfer to the fixing bath, the prints should again be allowed to drain for 15 seconds. For ordinary bromide paper I use only rapid fixing solution. This, however, requires treatment in a stop bath. Plain water is not enough. Some types of professional paper, as well as opal film, prefer an ordinary acid fixing bath. (Except opal film, films and plates must not be processed in the same fixing bath as paper.) Fixing time at temperatures above 18°C vary from 2–5 minutes in rapid fixing bath and 5–10 minutes in ordinary fixing bath.

The times are certainly not critical. On the other hand, 5 or 10 minutes respectively must never be exceeded, otherwise the fixing solution will attack the lightest, most delicate tones of the print. It is best to rely on a signal timer. If you are in the habit of collecting your prints in the fixing bath you must not expect perfect quality and delicate tone range. The prints must be collected in a dish filled with water.

In the fixing bath, too, you must not leave your prints to their fate.

Agitate the solution thoroughly when you first immerse them; occasionally repeat this during the course of fixation.

The final wash

Collect your fixed prints in a dish of water for the whole duration of your darkroom session. At the end transfer them to running water; single-weight papers should be washed for at last 30 minutes, doubleweight papers for an hour or even longer. If the papers had only a short time in the fixing bath, the rinsing time, too, can be cut down. Water temperature affects washing time, too. The lower the temperature, the longer prints need to be washed. If you have no running water available, you must change the wash water at five-minute intervals eight times for single-weight, 15 times for double-weight papers. If you do not carry out the washing conscientiously, you must expect your prints to yellow in time.

On the other hand, too much washing won't do any good either, as the prints will be exposed to bacterial attack. Prints should therefore not be left soaking overnight. If you cannot manage to glaze all your pictures in an evening, it is best to lay them out on paper to let them dry provisionally in air. You can soak them again as soon as you start another glazing session.

A great advantage of plastic-coated paper is that it need be held only briefly under the fully turned-on tap. This reduces the rinsing time from 30 minutes to a few seconds.

Drying prints

Before you glaze-dry your prints on a mirror or sheet of ordinary glass, thoroughly rub the glass down with methylated spirit, otherwise the prints may stick to the glass.

You can also use a sheet of plastic laminate stood upright. If you bend it, even firmly adhering dry prints will readily come off. The plastic sheet, too, must be rubbed down with methylated spirit at regular intervals. This cold drying method is more convenient, and produces a gloss superior to that of the hot method.

Obviously only the glossy surfaces should be glazed. All other paper surfaces are best dried in air. Both drying in air and cold glazing take their time. If you are rushed, the only way out is to use the hot-bed dryer-glazer. Single-sided glazers accept one, double-sided ones two chromium glazing sheets with prints. The sheet on the underside takes longer to dry and is best turned up once the prints on the top sheet have been removed and replaced by the next batch of wet ones.

It is by no means easy to obtain perfect gloss. Both for hot and cold glazing a few conditions must thefore be met to achieve the best possible results: it is necessary to make the surface of the prints very slippery. After the final rinse bathe them in a wetting or glazing solution to reduce surface tension.

The papers, emulsion side down, are now laid on the glazing sheet, which is regularly treated with methylated spirit. No particles of dirt must lodge between the sheet and the prints. Hot chromium sheets must be thoroughly cooled with water before they are re-used. Old drying marks are rubbed off with the ball of the thumb. The prints are first smoothed down with the finger, and then carefully pressed down with the roller squeegee; bubbles and creases as well as surplus water must be squeezed out. It is a mistake to squeegee the prints down too firmly. It does not do the gloss any good.

And now you have to be patient. If you remove the prints too early from cold sheet or hot press, the emulsion layer may break or at least crack. Just before the prints are completely dry they will crackle in the hot press. Only when the crackling has stopped, the apron is dry, and no more steam rises should the dryer-glazer be opened.

On the other hand, if the prints stay too long in the dryer-glazer, the heat will make them wavy. Single-sided dryer-glazers tend to develop more heat than is good for the prints; you can counter this by switching the current off for a few minutes every now and again.

The freshly-dried enlargements will at first curve slightly. On a smooth base they will flatten by themselves after some time. Air-dried prints must be flattened in books. Cold-glazed prints, on the other hand, will be completely flat from the beginning. Perfect gloss on plastic-coated paper presents no difficulties at all. The

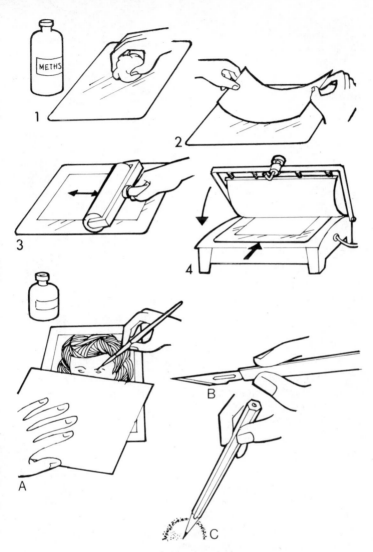

Glazing procedure: 1, Clean glazing plate. 2, Apply wet print to surface. 3, Squeegee to expel excess water. 4, Place in glazing press and tension apron. A, Spotting of glossy prints must be carried out with glossy dyes. B, C, Knifing and pencil work is possible only on matt prints or before glazing.

paper is simply dried in air, emulsion side up, or briefly on the dryer-glazer, emulsion side facing the apron, at a moderate temperature.

Spotting

No matter how thoroughly you clean your negative before inserting it in the negative stage of your enlarger you will hardly be able to remove the last speck of dust. You will eventually notice it when you discover white spots on the enlargement. They are particularly obnoxious in pictures with large, uniformly dark areas. Some photographers claim that they like spotting; for your sake I can only hope that you are one of them.

This is what you need for spotting and retouching in general: retouching dyes in various colours from black to zinc white and in matt and glossy; a No. 2 sable brush; a retouching pencil; a retouching knife for scraping.

Matt surfaces are comparatively simple to spot. Cover white spots in dark surroundings with matt retouching pencil. Small dark spots can be scraped. Bright spots on glossy paper must be removed with black, glossy dye; this requires patience. It is best to moisten the brush with saliva. Transfer a little dye from the pot to a slide coverglass and dilute it; take up no more than you need for spotting the offending blemish. It is simplest to start with the dark portions of the picture and to proceed gradually to the lighter ones. The brush should·be only slightly moist, especially when you are about to spot light grey areas with light-grey. The brush must be pointed, and the spot carefully covered with pigment. If a single application is not enough to make the spot disappear, wait until the pigment has dried, and apply another lot. Do not trace white lines (the result of scratches in the negative) with the brush. Use the same method as for spots: block them out dot-by-dot. It is possible to cover dark spots with zinc white, but this is not the best method. Farmer's Reducer (p 31) sometimes offers a better solution.

In certain conditions you might think of spotting the negative. Black dye can be used for this purpose only if the spotted area is to appear pure white in the enlargement. But if a white spot in

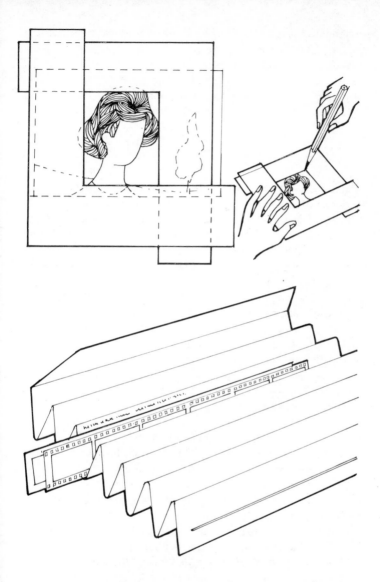

Top, L-shapes are useful for determining final trim of prints before mounting or other display. **Bottom,** Concertina-folded sheets of paper or thin card form useful files for strips of negatives and contact prints.

101

the negative is delicately covered with red-brown dye, it will appear in a grey tone in the positive. Spotting 35 mm and 6 × 6 cm (2¹/₄ × 2¹/₄ in) negatives in detail must, however, be regarded as almost impossible. A somewhat complicated but nevertheless very practical way out is to make a large-format intermediate negative. Spot it and produce a positive contact print of it.

Print trimming

I like borderless prints best. I therefore trim off all white areas, evidence of darkslides, books, etc. used to weight the paper.
A pair of scissors is very unlikely to produce a perfect trim. A paper guillotine or print trimmer works better, simpler, quicker and cleaner. The stop against which the paper is pushed ensures that the corners will be really rectangular. Unfortunately trimmers accepting formats beyond 24 × 30 cm (10 × 12 in) are fairly expensive. Giant enlargements are therefore trimmed with a blade (craft tool, razor blade, etc.) and ruler.
In spite of the greatest care horizons will occasionally slope or walls, chimneys, or spires threaten to topple over in the picture. Skilful trimming of the margins can correct this fault.

Print presentation

Albums accept photographs of up to 13 × 18 cm (5 × 7 in) without difficulty. But the particularly impressive formats from 18 × 24 cm (8 × 10 in) to about 130 × 180 cm (52 × 72 in) have their place without doubt on the wall. Or can you imagine a more personal room decoration than giant photographs you have taken and enlarged yourself?
Now it is not only the style and the subject of a picture, but also its presentation that must blend with your room. Let me therefore offer you a few very varied suggestions on the subject of picture presentation:

1 For rooms with a modern decor the pictures are "plastered" on the wall in ascending or descending patterns in their original

Mounting prints: 1, Apply rubber solution to mount and to back of print. 2, Position print carefully on mount. 3, Cover with clean paper and press down from centre outward with a straight edge. 4, Clean off excess rubber solution with cotton wool or dried rubber solution. A quick alternative mounting method is to use double-sided adhesive tape along the print edges.

state. The wall must disappear under a flood of photographs.

2 Borderless presentation under glass to match high-class decor. The photograph is sandwiched between glass; the suspension must be invisible. If the photograph was dried too hot, it will have a tendency to buckle even under glass; it should again be soaked in water for a few hours and cold-dried.

3. Borderless photographs mounted on stiff cardboard or plastic laminate without glass (for modern decor, display windows, exhibitions). Until recently it was rather difficult to mount prints on stiff supports. The glue-soaked cardboard, unless it was double lined, soon began to bend. Later dry mounting tissue became popular; this requires an iron or an expensive dry-mounting press. But dry-mounting tissue is considerably cheaper than cold-mounting sheets.

4. Picture blocks for prestigious rooms and business premises. The blocks are picture supports of considerable thickness, making the pictures stand out from the wall.

Large
and
Small Prints

From the principles of enlarging we can now proceed to practices that are interesting, but rather rare. In this chapter we consider very large reproductions and very small ones, black-and-white copies from colour, and the use of opal film.

Large and giant enlargements

Nothing is too banal not to become an object of admiration, as long as it is sufficiently blown up. Huge size has its own fascination. Even rubbish can be impressive – provided it is big enough. In view of this, how much more striking and imposing must a good picture become when it is enlarged to really huge dimensions. A picture, mediocre in postcard size, enlarged to 40 × 50 cm (16 × 20 in) will in fact make quite an impact. A picture already remarkable as a postcard may be absolutely sensational as a giant enlargement.

But the enlargeability of a negative has its limits. There is, to begin with, the available paper format. The easy-to-process sheets are supplied up to 50 × 60 cm (20 × 24 in). Rolls of 10 m (33 ft) length come in widths of up to 127 cm (51 in) for bromide paper and 132 cm (53 in) for photo-linen. If necessary, you could therefore make an enlargement of up to 130 × 180 cm (52 × 72 in). This is roughly a 54× enlargement of a 35 mm negative.

A perfectly sharp 35 mm negative on 100 ASA film should stand such enlargement without doubt. I should like to emphasize this although our survey on p 30 indicates 40 × as the maximum enlargement for a negative on 25 ASA film; but the data there refer to a viewing distance of 1 m; normally, however, one will look at a man-sized photograph from a distance of 2–3 m. In these conditions we can hardly complain about any lack of sharpness. You can enlarge all negatives – even those on ultra-fast film – up to 40 × 50 cm (20 × 16 in) without difficulties – unless these are imposed on you by dimensions of your darkroom and the range of your enlarger.

The smallest enlargers produce enlargements of up to 18 × 24 cm (8 × 10 in). With many models, however, the 40–48 in column allows enlargements up to about 60 × 90 cm (24 × 36 in) to be made.

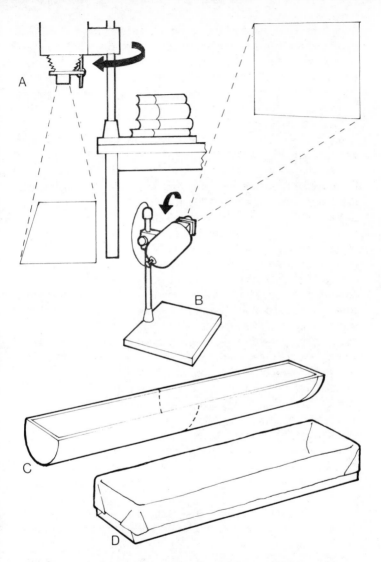

Making giant enlargements: A, Turn enlarger head round on column to project on to floor. Weight baseboard. B, Some enlargers enable the head to be turned to project on to a vertical surface. C, Plastic guttering can be used as a processing dish or D, a box can be lined with plastic sheeting.

Even if your enlarger does not have a long column, you can make giant enlargements either by horizontal projection or by projecting on to the floor or other surface below the level of the baseboard. To do this you turn the enlarger through 180°, so that the column rises from the front edge of the tables; then weight the baseboard with some very heavy books and rotate the enlarger head through 180 °.

Even in unfavourable conditions, floor projections will enable you to enlarge up to 50 × 60 cm (24 × 20 in), which is not bad at all.

If you are still not satisfied, try horizontal projection. Again swivel the enlarger head through 180° and place the whole enlarger on its back, as it were. Here, too, screw clamps will provide the necessary stability to the otherwise very rickety set-up. The negative is projected on the wall opposite, where the bromide paper is fixed with drawing pins or adhesive tape. The contact adhesive method, too, may in certain circumstances be useful. With floor projection you may have to adopt similar measures. The largest conventional size of masking frame is 30 × 40 cm (16 × 12 in). Magnetic masking frames are available up to 65 × 90 cm (26 × 36 in). They are metal plates on which the paper is held in position with magnetic strips. Such masking frames are eminently suitable also for horizontal projection.

I must not forget to mention the problem of stray light. Every enlarger emits stray light, which can be a nuisance in the darkroom. Its intensity depends very little on the enlarging scale. But the luminous density of the projected image rapidly decreases with increasing size. This naturally increases the effect of stray light on the exposure of the bromide paper. It converts those portions of the print that should really remain white into a delicate grey, reducing the contrast of the enlargement. It is thus often an advantage to use paper harder by one grade – if necessary even two grades – than you would need for enlargements of a more conventional size.

It may also become necessary to seal with black adhesive tape certain points on the enlarger head that let out too much light. For giant enlargements the exposure time often extends to several minutes, especially when you want maximum definition from your enlarging lens at f8 or f11. For enlarging scales beyond 20:1

A temple in Athens, the unpromising-looking starting point for various negative, positive and screen combinations. The next three pages show the component parts and stages in the production of the prints on the following three pages and on the page previous to this one.

Production of three density separations of
different contrast. First, underexposed,
correctly exposed and overexposed positives
are made on process film. These are re-
printed on to process film as frequently as
necessary to provide the contrast required.
The illustrations here are merely a few of
those produced. The negatives and positives
finally used are those that eliminate all the
intermediate grey tones.

Left: Tone separation. Using a registering device, first a hard shadow negative and then a very soft, thin highlight negative were contact printed on to bromide paper.
Right: The so-called "isohelie". Three hard separation negatives (first, second and fourth in the end row on the previous page) were successively contact printed on hard paper at different exposure times.

Right: A variation of the screen isohelie without the fourth exposure. *Below right:* Screen isohelie according to the colour isohelie method with exposure of negative-positive combination. An additional hard positive was exposed, making a variation between this result and that on page 109.

Below: This screen isohelie is produced by the same method as the normal isohelie but a line screen foil, in varying positions, is introduced between the negatives and the paper. A fourth exposure was made through the screen but without the negative.

Pages 114-116: Further results of combining various negatives and positives of the same subject with bas relief and solarisation effects added.

you can, however, use your camera lens quite succesfully provided it can be mounted on your enlarger. Here I use my 5 cm Summicron f2 with an adapter ring. This lens reaches its optimum performance at f4 and allows me to use relatively short exposure times. Its large maximum aperture also considerably brightens the projected image, which with giant enlargements is, after all, rather dim, and facilitates focusing and selection of the area to be printed. If you have not a suitable camera lens, you may be able to reverse your enlarging lens when making giant enlargements.

Processing big enlargements

The last problem to be discussed concerns development. It confronts you with new difficulties. You can, it is true, buy giant dishes – at corresponding prices; they also consume giant quantities of solutions. Alternatively, you can use trough or sponge development.

The first method requires a trough each for developing and fixing. The trough must be a little longer than the width of the paper (roof gutters welded together end-to-end or the plastic covers of strip lights are suitable). Grip a narrow side of the paper with each hand and pull the whole sheet repeatedly through the developer across the bottom of the trough. Use the same procedure for fixing.

Since you have to immerse your hands in the chemicals, the wearing of rubber gloves is strongly recommended.

This also applies to sponge development. Here you also need a waterproof base (plastic foil or silver-paper-covered protective envelope for photographic paper). Place the exposed bromide paper on this, emulsion side up. Dip a sponge – a natural sponge – in the developer and allow it to soak itself full. Wipe the entire paper surface with it – until the image builds up really vigorously. Do not be stingy with developer – it must form real puddles on the surface of the paper. My first sponge-developed enlargement seen in bright light showed distinct streaks. My sponge was too dry.

The print must be fixed in the same way, but obviously with a different sponge on a different base. The prints are rinsed in pails

or tubs. To finish the procedure the print is dried in air or cold-glazed on a sheet of plastic.

Giant photographs, by the way, are suitable not only for the decoration of your living room, but also for various other purposes. If you own a shop, for example, you might decorate the display windows in this way. Giant enlargements might also be used as advertising posters or props for school theatres or dramatic societies.

Photosensitive fabric (photo-linen) is particularly suitable for such props. Since, unlike paper, it can, within reason, be folded, it should be possible to develop comparatively large formats in small dishes.

Mini-enlargements and reductions

Reduction, same-size copies, and slight enlargements play a much more important role than might appear at first glance. Manipulation of the print (contrast improvement through masking) photo-"graphic" tricks and, surprisingly, also experiments with colour are based initially on small black-and-white positive and negative enlargements.

For contrasty work I prefer process film and I always place black paper under it for the exposure. A light support may reflect the light reaching it and produce undesirable densities. Most process films can be handled in red darkroom light. Development should be by time. After all, the pictures can be assessed only after they have been cleared in the fixing bath.

Here are the most widely-used copying methods both for positives and for negatives. You are already familiar with the contact printing processes. Nevertheless I would like to draw your attention to them once more. Copies you need as originals for graphic creations are preferably obtained with the contact method.

Contact method for single transparencies

Place the negative or transparency emulsion side down on the sheet film. Weight it with a sheet of glass or – to avoid dust – with

118

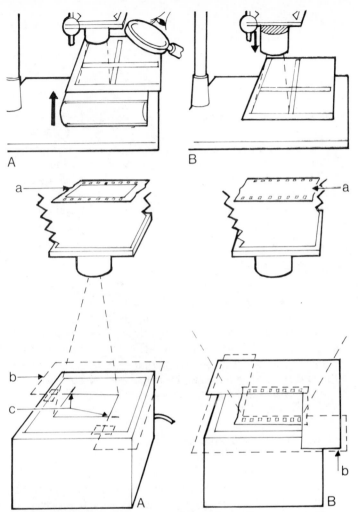

A

B

a

a

b

c

b

A

B

Top, Making reduced prints: A, Some enlarger heads cannot be lowered far enough. Raise the masking frame on books. B, Extension tubes may be necessary to increase lens-to-negative distance. **Bottom**, Copying with the enlarger: A, Project focusing negative on to light box for required size and sharp focus. Place one L-shape (**b**) and mark corner positions (**c**). B, Replace focusing negative with copying film, place original on light box and position second L-shape to complete mask.

the masking strips of the masking frame. If the contact with the support is not very close, improve sharpness by stopping the enlarging lens well down. Copies are of exactly the same size as the originals.

Contact methods for large quantities

Place several negatives or transparencies on large-format sheet film and expose them uniformly. To ensure flatness of the original negatives or transparencies, a sheet of glass will mostly be necessary. If possible, select originals of similar density for a given exposure. To begin with, make trial strips. Copies and originals are exactly the same size.

Reductions with the enlarger

Insert the transparency or negative in the negative carrier. Lower the enlarger head radically. Extend the enlarging lens considerably; sometimes an extension ring will be necessary. It is nevertheless impossible in some enlargers to obtain a sharp image on the masking frame, because the enlarger head cannot be lowered sufficiently. Here the masking frame must be raised (place it on books). Always check the sharpness with a reading glass.

Reproducing with the enlarger

The enlarger is used as a camera. The film material is inserted in the negative carrier. The negative or transparency is placed on a light box or transilluminated groundglass screen on the baseboard. The original is exposed when the light of the light box or below the groundglass screen is switched on. To obtain accurate exposure, it should be switched through the exposure timer.

As a first step, focus and picture area must be determined once and for all with the aid of a suitable test negative, to be inserted in the negative stage and focused on exactly the area the negatives or transparencies to be copied will occupy.

Reproducing with the camera

The negative or the transparency is transilluminated as described above and photographed with the camera, which of course must have facilities for near-focusing and macro-photography.

During reproduction with the camera, dust, fortunately, is far less in evidence than with any other method. If the camera is loaded with black-and-white reversal film, you can obtain positives from positives and contrastier negatives from negatives. The material is usually sold process paid and is returned to the distributors for processing.

Black-and-white enlargements from colour films

Black-and-white pictures can be obtained from any colour negative, whether masked (orange-coloured background) or not (white to yellowish background). The orange colour of the mask, however, requires a somewhat longer exposure. Colour translation into grey tones is slightly unusual compared with that of black-and-white and unmasked colour negative film. Whether this is an advantage or disadvantage in any given case you will very quickly find out with the aid of a contact sheet.

Black-and-white pictures can be obtained from colour transparencies via intermediate negatives. Transparencies that had a short exposure and contain mainly dark tones are best suited for this process. If the normal panchromatic material is used for the intermediate negative, the black-and-white prints will look as if the negative had been exposed through an orange filter. The warm, orange-tinted light of the enlarger lamp is responsible for this; it renders the blue tones in the picture lighter, the red tones darker.

A blue filter can destroy the orange-filter effect, but that is not always desirable, because in 9 out of 10 cases this effect enhances the impact of the picture. As during the exposure, we can by means of colour filters influence the negative character during the copying of colour transparencies in a fairly arbitrary way.

Another, even simpler possibility of producing enlargements from colour transparencies is to enlarge the transparency on opal

film. You will obtain a negative print with which to make contact prints on bromide paper. Such pictures readily stand comparison even with enlargements from intermediate negatives.

Uses of opal film

I would call the opal film a hybrid between film and bromide paper. It is available in sheets from 13 × 18 cm to 50 × 60 cm (24 × 20 in) and in rolls from 5 m (17 ft) onwards at a width of 110 cm (44 in). Unlike the usual film this coated triacetate foil is not transparent, but only translucent. An enlargement on this material transilluminated looks somewhat like a genuine black-and-white transparency in front of a transilluminated groundglass screen. By reflected light, however, it resembles a glossy photograph. The only grade available is "normal". A negative of average contrast therefore produces an opal-film picture of a pleasing tone scale.

If we think of it, this can really apply only to viewing by reflected light. I have already pointed out several times that transparencies appear brilliant only when they are extremely contrasty. A picture on opal film that appears just right by reflected light would naturally look much too flat when transilluminated. In theory this is quite correct. But a very ingenious practical solution overcomes this snag: the back of the foil is coated with a second light-sensitive emulsion. After exposure and development it produces a second – usually slightly unsharp – picture; this is of course visible only in transmitted light; but here the densities of the front and the back emulsions add up: Dark grey + dark grey = black, light grey + light grey = grey, but white + white remains white. Transillumination thus effectively increases the contrast, which to some extent can even be controlled: the back picture will be lighter when the exposure is made against a dark, and darker when it is made against a light background.

The material is processed exactly like bromide paper – if necessary even in the same solution. The developing time ranges between 1^1/$_2$ and 2^1/$_2$ min at 20° C. A stop bath should be used. After the rinse and wetting bath, string the sheets on a washing line with laundry pegs. Opal film dries surprisingly quickly, it always

sparkles in oystershell gloss, without oystershell marks or waviness. A mirror or dryer-glazer is unnecessary. If you fail to obtain perfect gloss on large-format prints after repeated attempts, use opal film or plastic-coated paper.

Triacetate foil can be cold-mounted on smooth surfaces. Opal film creates a special effect in positive pseudo-solarization. The front emulsion is solarized, whereas a normal image is built up in the back. If you contact-print such an opal film on bromide paper, you will produce a combination of solarization effect and a negative print (starting with a negative) or a positive (starting with a positive). Enlargements on opal film are also useful as "intermediate products" for many applications.

Special
Printing
Techniques

The character of some negatives makes the choice of the most suitable paper grade very difficult indeed. Imagine an interior with large windows opening onto a mountain panorama. Let us assume that the features of the room will appear normal on normal paper. But in front of the window is a prominent white spot. Longer exposure in the enlarger, true enough, produces a wonderful panorama; but everything inside the room is then pitch black. The problem can hardly be solved with soft paper. Extrasoft might conceivably reproduce both mountains and room at reasonable clarity. Unfortunately, both will be so flat and uninteresting that the picture loses all impact.

Holding back and printing up

There is only one remedy for this: use normal paper, but give different exposures to the two features. In most cases, holding back and printing up techniques can be used for such purposes. As "dodgers" to hold in the light beam to manipulate the exposure, you can use your hands or pieces of black card or paper attached to a thin piece of wire.

These are used in various ways according to the nature of the problem. If, for example, you have the edge of a bright wall in front of a dark background, ideal exposure times might be 20 seconds for the bright and 4 seconds for the dark part of the picture. You then divide the total exposure into two part exposures of 16 and 4 seconds.

For the first exposure, the enlarger lamp is switched on for 16 seconds, during which time the excessively bright part in the negative (dark in the positive) is completely covered with a piece of opaque cardboard. To soften the boundary between the exposed and the unexposed parts of the picture a little, slightly move the cardboard to and fro across the boundary region. An abrupt change of brightness would betray your trick.

For the second part exposure, the entire picture is exposed for 4 seconds.

The boundary between the too bright and too dark parts of the picture may be irregular, as in a dark mountain range in front of a bright sky. Choose the exposure so that the brightest part of the

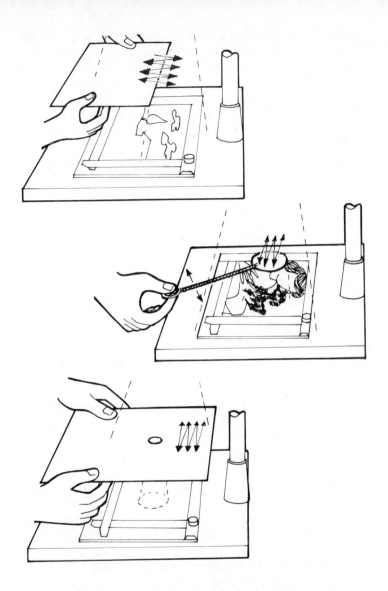

Top, Shading or holding back to prevent foreground area printing too dark. **Middle,** Holding back small portion of image. **Bottom**, burning-in or printing-up small portion of image.

127

picture in the positive is well exposed. While the enlarger lamp is switched on cover the parts of the subject threatening to become submerged in detailless shadow with your hands or a piece of cardboard. Carry out rapid to-and-fro movements, trying to follow every single curve in the boundary zone. Real success can be expected only if the exposure is not too short (stop down the enlarging lens, use a lamp of weak power, insert grey filter in the filter drawer).

Do not expect to succeed at your first attempt. Try until you do – it is worth the effort.

A trickier example is a blocked-out dark subject detail in the centre of the picture. Such as a black poodle casting a shadow on a light cushion (soft paper would turn the black coat grey). Hold back the light in the centre of the picture with a star-shaped dodger at the end of a wire. The wire must be long enough to prevent your hand from entering the picture area by accident, holding back marginal portions.

Introduce the dodger from all sides – left, right, top, bottom – and move it vigorously in the centre. Conversely, you might have a too bright detail in the middle of the picture, such as the sun through a window in the nave of a church. Window frames and frescoes on the dark church walls are to be reproduced as clearly as the window. Ideal exposure for the window could be 30 sec, for the nave 8 sec. Again make two part exposures – 8 + 22 sec. First expose the whole area for 8 seconds. Then, for the 22-second exposure, cover the whole negative except the window with a piece of cardboard with a hole appropriately positioned to expose only the window. The hole should be about as large as the subject detail to receive the second exposure. The cardboard should be larger than the bromide paper, so that it covers it completely while you move it slightly throughout the exposure.

Carry out your first experiments with negatives you can enlarge on soft or normal paper, because hard, not to mention extra-hard material is more difficult to dodge. Exposure and switch-off times must be matched with the utmost precision – which is not easy. It is also useful to "rehearse" the dodging movement on the image projected on the empty masking frame.

If very complicated features – trees, antlers, people, rapidly moving animals – are to be isolated from the background simple

dodging is no longer enough. Here masks or "dodging masks" offer the only way out.

Isolating and masking

To keep our waste paper baskets full to the brim, the post brings us daily masses of lavishly illustrated prospectuses. These contain a great many photographs that are completly isolated from their surroundings – which ought to interest you. The main subject is completely suspended in front of a dark or light background. How is this done?

There are various methods, such as blocking out the unwanted detail on the negative with dye or special blocking-out medium, bleaching out and masking.

The larger the format on which you work, the less the difficulty. Unfortunately there is only one instance when you can modify a finished paper enlargement (the very ingenious stripping varnish/reducing method). In all other cases the negatives or intermediate transparencies must be treated. To mess about with a 35 mm or 6 × 6 cm ($2^1/_4$ × $2^1/_4$ in) negative is completely futile. The results never justify the effort. Make intermediate negatives or positives on film or opal film, minimum size 9 × 12 cm; 13 × 18 cm or 18 × 24 cm is more convenient. These will then be blocked out with dye or adhesive tape. The final picture (or another intermediate product) will be produced by contact printing. After this preamble I am going to introduce the most important methods in detail:

Isolation of subject on white background

1 Carefully paint background on the negative with black or red retouching dye. Contact-print. This method is not suitable for subjects with straight outlines.

2 Block the background of the negative with adhesive tape. This method is suitable only for subjects with straight outlines (modern architecture, interior decoration). If the subject requires it, use both retouching dye and adhesive tape.

3 Thickly paint subject of final paper enlargement with stripping varnish. Remove background completely with Farmer's Reducer. Now detach varnish on one corner and strip it off the print. A most convenient method. Brief reduction merely lightens the background. Make certain that every detail of the subject is covered with the varnish.

4 Cover the subject on the negative with stripping varnish; bathe the negative in red ink or red retouching dye. Dry, strip the varnish and make a contact print. Dye can be removed through rinsing (opal film not recommended).

5 Make a hard mask (background black, subject translucent, see page 164). Mount with negative in precise register. Make contact print.

Isolation of the subject on a black background

1 Make an intermediate transparency. Paint background with black or red retouching dye. Via a further negative make a contact positive.

2 Subject with straight outlines: block intermediate transparency with adhesive tape. Proceed as above.

3 Paint the subject in the negative with stripping varnish (do not use opal film). Remove background with Farmer's Reducer. Brief reduction preserves the background; this, however, will become darker in the positive.

4 Make a hard mask (subject black – background transparent). Make a contact print. Expose first through the normal negative. Second exposure through mask. (Short second exposure merely makes the background darker). This method can be used only with the aid of the registering device to be described later.

Masking is a difficult procedure but it can be simplified with the aid of the simple registering device described on p 159.

We need masks not only for isolating our subjects. Delicate contact positives bound together with a negative reduce the picture contrast. These isolating masks must of course also receive some after-treatment so that they cover only the subject proper or the background.

On hard negatives or positives, the subject, for instance, is protected with stripping varnish, the background removed, and the subject blocked out with black dye. Sometimes it is also advisable to remove the main subject. It all depends whether it is easier to remove the background or the subject. Only where background and object tone are light-and-light or dark-and-dark is it necessary exactly to trace the contours with varnish on the one hand and with dye on the other. Where black abruptly meets white, you may splash varnish across the boundary with impunity.

Another method of holding back the background is feasible for enlargements from 18 × 24 cm (8 × 10 in) upwards. The negative is first projected on a sheet of cardboard, the outline of the main subject traced, and this cut out. The cardboard with the shape of the subject cut out is held about 5 mm above the bromide paper during the exposure and moved to and fro. This is followed by a second exposure of the entire picture. If a subject in the centre of the picture is to become lighter, the cut-out is mounted on a glass plate and moved as before. This method should be of interest with subjects whose outlines are not too complicated.

Reducing methods and procedure

The object of reducing is by no means confined to salvaging enlargements that are on the borderline of failure. There is a number of chemicals that can be used for reducing, and opinions of them differ among photographers; some won't touch them at all, others treat almost every – or at least every other – print with them.

The truth, as usual, is to be found somewhere in between. With one type of reducer, Farmer's, you can indeed give the final polish to many prints. Your darkroom should not be without it.

Farmer's reducer is available in powder form from various manufacturers but its formula is in innumerable photographic reference books. It consists basically of a 10 per cent solution of potassium ferricyanide and a 20 per cent solution of sodium thiosulphate (hypo). You add one part of the ferri to anything from 5 to 50 parts of the hypo. The higher the ferri content the stronger the bleaching action. You should mix the two solutions only as

required. Once mixed they decompose rapidly. The separate solutions keep indefinitely.

If we allow the reducer to act on an enlargement or negative briefly, it will, to begin with, attack the lightest portions, making them lighter still, thereby increasing the contrast. Reduction of a positive brightens the highlights; reduction of a negative ultimately produces vigorous blacks in the enlargement. In almost all, or at least in very many, prints the highlights are slightly grey. We can also deliberately give a generous exposure to our prints to obtain really "gutsy" blacks, and "clean" the highlights with reducer. Black-and-white transparencies should always be treated in this way. Enlargements of silhouettes or other graphic features, too, usually show a slight greyness in the light surrounding field if they had been exposed long enough for the dark silhouette features to be really jet-black. Here, reduction must be balanced so that the light grey just disappears before the black is attacked and degraded into grey.

Here is another piece of advice: you cannot allow a part of the print to become completely blocked, and then lighten it with Farmer's Reducer to a uniformly grey area, because the reducer will recreate the original structure from the black. The only way to do it is to make an intermediate negative or positive in which the relevant area appears completely transparent. In the new print the black expanse can now be reduced to a uniform grey (this of course requires that the other details of the picture are covered with varnish).

Reduction can be carried out on paper prints, negatives, and transparencies. If they have just been processed, they should be briefly rinsed in water after fixation before they are transferred to the Farmer solution. Dry prints of any age should first be thoroughly rinsed. Grease spots on old negatives and transparencies must first be removed with a piece of cotton wool soaked in methylated spirit.

If the reducer is too strong, the print will be attacked very rapidly and probably in patches. It is better to use a relatively weak solution, to reduce the power of the reaction. One part ferri solution to about 20 parts hypo should work reasonably slowly.

A sheet on which everything is to be removed except a small area covered with stripping varnish stays in the reducer until the de-

sired effect is achieved. But if only the highlights are to be cleared, the reducer must be prevented from attacking parts of the print that are to be preserved. This is done by removing the print after a short time in the reducer to a water bath. After detailed inspection it is returned to the reducer, and this procedure is repeated until the desired result has been obtained. The reducer may in certain conditions continue to act even after the print has been transferred to the water bath. This must be allowed for. Finally the print must be once again fixed for 1 to 2 minutes, and then rinsed and dried as usual.

The reduction of original negatives should be risked only if they are hopelessly dense. It is a good precaution to make a duplicate negative via an intermediate positive. Stabilization papers cannot be reduced unless they are first fixed and washed.

Applications of reducer

Here is a survey of the many things you can do with a reducer:

Increasing the contrast of paper prints

The whites are cleared, the highlights brilliantly brought out. Most prints will at least not be harmed by a brief immersion in reducer. Some photographers make a habit of slightly overexposing their enlargements and putting them through Farmer's Reducer afterwards. Enlargements of landscapes in contre jour or glancing light thus acquire added sparkle. In portraits, reducer brings out the whites of the eyes and makes the teeth bright. Care must, however, be taken that the reducer does not attack the brightest portions of the skin. "Burned-out" skin tones look horrible.

Brightening of badly overexposed paper prints

Reducing will often, if not always, be successful. But it matters little whether such a print is consigned to the waste bin before

reduction or after a failed attempt at it. The experience gained provides an insight into the effect of the reducer on various tones and a guide for future action.

Removal of grey tones from photographic prints

To obtain a perfectly white background for silhouette enlargements reduction is almost always necessary. It is absolutely essential with positive pseudosolarization, where no tone normally reproduces as a clean white, owing to the overall fogging effect of the second exposure.

Isolation of subjects

As described on p 130 part of an enlargement or a negative can be covered with stripping varnish. The remainder of the picture can now be brightened or completely removed with the reducer. After rinsing, the varnish is carefully stripped off.

Partial reduction of prints

A piece of cotton wool is soaked in reducer. The parts of the print to be reduced are dabbed and wiped with it. For the treatment of marginal zones place the print on a sloping surface, with the portion to be treated at the bottom of the slope so that the reducer can do little damage as it drains off.

Clearing of transparencies and line negatives

Transparent portions of black-and-white transparencies regularly turn grey after drying. Transparencies should therefore always be briefly treated with reducer to produce more brilliant highlights in the projected image. Negatives of drawings, plans, etc. should also be so treated to allow the minimum exposure during printing or enlarging, so that maximum contrast can easily be attained.

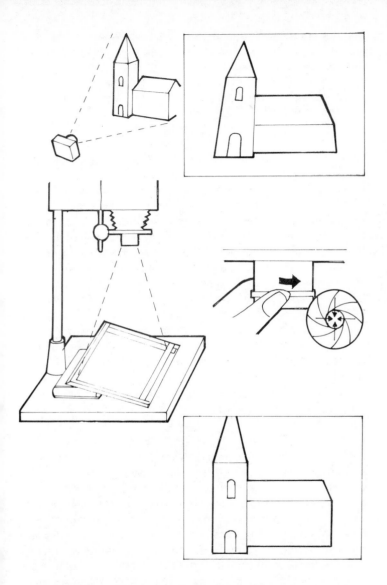

Correcting converging verticals: **Top,** Tilting the camera causes vertical lines on negative to converge. **Middle,** Raise masking frame at converging side and stop down lens to retain overall sharpness. **Bottom,** Corrected print.

Increase of contrast of overexposed negatives

The brightening of the brightest parts of the negative brings about an improvement of the blacks in the print. Irreplaceable negatives should be reduced with particular care, and should always be copied first.

Correcting converging verticals

Buildings or townscapes are a little more difficult to photograph than landscapes or people. Without really noticing it you often tilt the camera up or down during the exposure. The result, especially when you use a short-focal-length lens in the camera, is that walls and towers appear to lean backward or forward – usually backward because of an upward tilt of the camera. A slight lean like this is disconcerting, but a deliberate slant, with the camera pointing obliquely up or down, often creates a most effective photograph.

The enlarging process enables you to straighten slightly leaning buildings. On the other hand, the tilt of buildings can be increased by distortion so that an interesting oblique view is produced.

In practice we must distinguish between the improvised "primitive" corrections and "de-luxe" correction with specially equipped enlargers.

With improvised correction the masking frame is simply raised on the side of the projected image towards which the normally parallel lines diverge. Two or three books may be suitable for this purpose. Graph paper inserted in the masking frame affords accurate control of the parallelism of the corrected lines in the image. This correction becomes difficult when the camera had been not only tilted upwards or downward but also swivelled sideways during the exposure. In theory we would have to tilt the masking frame around the longitudinal as well as the transverse axis. Although this problem can be quite effectively solved with the aid of a correction device and a tilting negative stage, it is all but impossible to solve with primitive measures. In addition, four other disadvantages must be considered.

The picture area cannot be fully utilized: correction of converging verticals distorts the picture area into a trapeze. Two margins must therefore be trimmed off to re-establish the rectangle.

The subject is slightly stretched. A building, for instance appears taller than it really is.

At full aperture, only a small part of the projected image will be completely sharp. Care must be taken that the sharpest area occupies roughly the centre of the picture; the lens must now be stopped down as much as possible. It is the problem of sharpness which imposes the strictest limitations on primitive correction.

Intensity of illumination decreases appreciably from the higher part of the masking frame, which is closer to the light source, to the lower part. The light must therefore be slightly held back from the higher part with a piece of cardboard to ensure uniform density across the print.

Even the de luxe method involves holding back and print trimming. But correction devices cope easily with the falling-off of sharpness and fairly well with the elongation of the object.

Whether such correction devices are built into a professional enlarger or supplied as accessories, they all function on the same principle as the accessory for my Leitz Focomat:

The baseboard of this enlarger has grooves in which the masking frame is clamped; but a tilting unit can quickly be inserted between baseboard and masking frame, and the latter adjusted as necessary. (It can also be rotated, which makes further interesting effects possible). An additional device, the film holder tilting device, replaces the film guide in the negative carrier; it is now possible to arrange the negative in various oblique positions. Tilt your piece of film in exactly the opposite direction to that of the masking frame. Sharpness will now be absolutely even across the entire picture area. With large projected negatives this can be checked even with the eye.

First tilt the masking frame until the disturbing lines run parallel. Then tilt the film in the opposite direction. If you do not wish to rely entirely on your eye when you tilt the negative, the following point may be of interest to you:

Imagine the bromide paper on the masking frame continued on the higher side. Imagine also the piece of film continued, but in the downward direction. Lastly, imagine that the lens is bisected

by a plane, represented e. g. by a piece of cardboard. This plane runs parallel to the ground. Somewhere the extension of the masking frame will intersect the plane bisecting the lens. The negative must now be adjusted so that its extension, too, intersects the lens plane in the same point.

Unfortunately, however, the subject, as I have already mentioned, will appear elongated in the print. Although you cannot eliminate this effect entirely, you can do something about it. Pull the negative from the carrier as far as possible in the direction in which the masking frame slopes downwards. If necessary displace the whole tilting unit or only the negative in the holder; the alignment of the negative must, however, on no account be disturbed. The possibilities of adjustment are limited. You will reach a position where the lens mount or other parts of the enlarger cast shadows on parts of the picture area. You should, however, make full use of the latitude you have, particularly with horizontal pictures. You can thus slightly compress the elongated subject. But the masking frame must be adjusted to the new situation; it must be both displaced and tilted more strongly.

Graphic
Effects

If only pure whites and pure blacks are to remain, all grey values must be eliminated from the picture. "Eliminated" is perhaps not the right word: what we do in practice is to convert light grey into white, dark grey into black tones.

Occasionally you will be successful simply by printing a negative on ultra-hard paper. But the negative must be suitable. Contre-jour subjects and silhouettes may sometimes lend themselves to this procedure, especially when the film has received fairly long development. A slight grey tone in the highlights can be easily cleared with Farmer's Reducer. If you have graphic effects in mind from the outset, use slow film, even a process type.

Single-step processing may occasionally be successful at the first attempt, but this is the exception rather than the rule. Usually processing requires several steps. I am offering you a choice of four such methods:

1 Photogram technique: make a paper negative on ultrahard paper by contact print. Obtain a positive by a second contact print. If necessary, repeat this procedure.

2 Reproduction of an original: again start from a hard enlargement. Reproduce it on line or process film with the camera or the enlarger.

3 Production of a hard intermediate negative. An intermediate negative is made by contact or enlargement on line or process film. If required, a hard intermediate positive is now made, to be followed by another intermediate negative. For some experiments in photographics this game can (or must) be repeated as often as desired or necessary.

4 Photo copying of an original; many wet office copying machines produce vigorous blacks. An ultra-hard enlargement is copied exactly like a letter. In this way I have added the final touch to entire series of graphic compositions. Xerographic dry copiers, too, produce interesting results. Dark areas are not printed in deep black. Everything that appears black in the original will be reproduced white with a broad rim, which becomes unsharp towards the inside, on the copy. With the aid of a stabilization processor you will obtain graphic effects very quickly indeed, especially when you make use of the possibilities the contrasty technical papers and transparent foils offer you. Copying is no

problem at all with the enlarger, and better still with the contact method. A basic decision must be made with all graphic methods: which of the grey values are to be turned into white, which into black? This depends in the first instance on the first intermediate exposure.

Long exposure: even light-grey tones turn black. Picture contains much black.

Medium exposure: grey scale is divided at about medium grey.

Short exposure: even dark grey tones become white in the course of the copying process. Little black in the picture.

The negative "print"

In some of the copying methods just described negative prints, i. e. negative enlargements, are obtained as a by-product. You will notice that these will often make a very interesting impression. You need not be surprised that a genuine negative sometimes looks uninspiring, whereas you may be most positively impressed by a negative print of the same negative. Normally, negatives are soft. We can, however, start from the assumption that negative-print graphic effects make the greater impact the contrastier they are. The simplest negative print is made by the direct duplication of an enlargement. Negative prints can, however, also be made of any colour transparency. Since colour transparencies are as a rule very contrasty you have a good chance to produce a very striking picture on ultra-hard paper straight away. Soft negative prints, combined with a same-size black-and-white or colour transparency but slightly offset produce an interesting relief effect.

Grain structure

Perhaps you will decide one day to blow up a somewhat coarse-grain negative on fast film to a giant enlargement. At a certain enlarging scale the contours of the picture simply disintegrate and the picture becomes completely unsharp. If you blow it up even more, the picture not only grows further in size, at some stage it

begins to become sharper again; but now it is no longer the contours that are pin-sharp, but the silver grains.

The grain structure becomes more pronounced if you keep your enlargements as hard as possible. I am glibly speaking of grain structure, when in reality the dark spots do not represent the individual microscopically small silver grains, but only the small clumps of silver grains, which we can regard as the fine structural elements of a photograph.

Now you know that you can salvage certain types of unsharp photograph by enlarging a tiny portion of it extremely hard and to an extreme size. But you must ask yourself whether this makes sense. I start from the assumption that it is the object of every picture, whether photograph, drawing, or painting to enrich the conception of our environment with some new information. What will become of the information if we bring out the grain structure at the expense of the contours of our subject?

We are changing, as it were, the level of information. Every picture is composed of minute parts. The more clearly these basic constituents present themselves, the less clear will be the form of the object. We thus increase the information about the basic structure and suppress the information about the object. As we shall see later, the reverse procedure is also feasible. Let us choose an object and multiply it with the enlarging process to form a row, or mirror it (kaleidoscopic pictures). This makes it in turn into a structural detail of a newly created pattern. Let us assume that we use a little gear wheel as a subject and print it in a row so often that we create an ornament. We would now have a decorative composition with at least three levels of information. With increasing enlargement – image enlargement or closer approach of the eye – ever finer structures will become visible. At little enlargement we see chiefly the pattern, at medium enlargement the individual object, and at very great enlargement the grain structure.

Screen texture

Those pictures in which at least two levels of information compete with each other for our attention interest us particularly.

This is quite easy to understand. Science and technology today are engaged mainly in the transmission, storage, and processing of information. Since to us the most important photographs are those which – deliberately produced by the author for this purpose or achieved by him quite spontaneously – deal with problems of our environment, photographs that reveal something of the fine structure of the picture are quite justified. Now pictures are artificially screened for instance for communication or multiplication in printing. Even by screening we can therefore transform certain subjects most effectively. The simplest method is to use the transparent screen foils available from suppliers of artists' materials. With adhesive foils you can improve even finished enlargements. (But for copying, foils without adhesive coating are more suitable; unfortunately they are somewhat difficult to obtain).

The foils have patterns of lines of varying thickness, squares, dots, wavy lines. Some imitate the grain of wood or courses of bricks.

Place the screen foil on the bromide paper in the enlarger, and expose. You can also place it underneath objects for photograms. The screen treatment is particularly effective with contrasty subjects. Pictures rich in tone values are not usually very appealing.

The accompanying table shows the various methods of screening for enlargements as well as for photograms.

I am inclined to prefer natural screens to screen foils. Silk scarves, nylon stockings, lace, any loosely woven fabrics. These can, if necessary, also be placed over the negative in the stage. Whereas structures placed on paper will always be reproduced at natural size, if they are sandwiched with the negative stage they will be magnified to macro size, e. g. to 5 : 1 with a 13 × 18 cm enlargement.

Do not forget that you can make your own, quite original screens. All you have to do is photograph interesting natural ornaments such as the grain of wood, courses of roof tiles, lattices, cobble stones. Enlarge these photographs on 13 × 18 cm or 18 × 24 cm line film. Place the positives, or the contact negatives obtained from them, over the bromide paper like screen foils during enlargement.

Methods during enlarging	Methods in the photogram technique	Effect on black white parts of the picture	
Paper is exposed with screen on top	Screen on bromide paper, object on screen	Appear white throughout	Screen produces white textural lines
Paper is pre-exposed or has second exposure through the screen, without a negative in the negative stage. Negative is exposed separately on paper without the screen	Paper is pre-exposed or has second exposure through the screen without object. Additional exposure with object, without screen	Appear structured through the screen	Appear black throughout. With short exposure black textured grey tones will be obtained
Paper is exposed without negative through screen I (e. g. horizontal bands). The second exposure is through the negative and screen II (screen I rotated through 90 (vertical bands) or displaced): or other screen	Paper is exposed first without object through screen I, then with object on screen II	Appear textured by screen I	Appear lightly textured through screens I and II
Screen I remains on the paper during pre- and second exposure. Screen II is additionally placed only during the pre-exposure without negative	Screen I remains in position during pre- and second exposure, screen II is placed on the paper only during the pre-exposure without the object.	Appear textured by screen I	Appear textured by screens I and II

Pseudo-solarization of bromide paper

By manipulation in the darkroom, the bright picture areas can be made to reproduce black, while prominent boundary lines occur between the strongly contrasting dark and previously light areas. Copying produces black lines on a white background.

Halftones can appear partly positive, partly reversed to negative. With further copying all halftones can be resolved into lines.

I am talking about the Sabattier effect. Usually it is called solarization. But as this is technically not quite correct, the term pseudo-solarization has recently become popular. Perhaps you will hear or read that the pseudo-solarization effect cannot be perfectly produced on bromide paper. Do not let this discourage you from risking a few sheets of paper. Such assumptions are simply not true.

You will reach your aim most quickly if you start with a hard negative, an enlargement on ultrahard paper (as contact original), or a brilliant transparency. (Although it makes a difference whether you use a positive or a negative as an original, both will produce equally impressive compositions.)

Here is my procedure in detail:

1 Enlarge a hard subject on ultra-hard paper. Adjust the exposure so that normally an enlargement with good detail is obtained.

2 Develop it for 50 to 70 sec in fresh developer at 20° C. The detail must already be clearly visible.

3 Expose the print floating in the developer to bright light (note: keep unused paper in a lightproof place), e. g. to a 100 W opal lamp in an opal bowl for about 1 sec at a distance of 100 cm (40 in) from the developing dish.

4 Wait for the bright parts of the paper to turn black. This may happen very quickly. Do not agitate the bromide paper in the dish after the second exposure, so that the formation of the lines will not be disturbed. As soon as the bright portions have turned completely black, transfer the print to the stop bath. Do not wait too long, otherwise the fine lines will be lost. They look in any case rather grey and muddy at first.

5 After fixing and a brief rinse (or after drying) immerse the print

in Farmer's Reducer to clear the bright lines; do not allow the black portions to become affected.

6 If necessary, copy the print twice (contact print) to bring out the effect even more strongly. This is recommended particularly when owing to excessive exposure or development the lines have become blocked to the extent that they can no longer be effectively cleared in the reducer. Negative prints of paper pseudo-solarized pictures, too, look impressive with their black lines on white background.

Your working method may require exposure and developing times different from mine. If you were unlucky with your pseudo-solarization experiment you are sure to want to know why. The following list will enlighten you:

1 The paper has become completely black or at any rate much too dark. Reason:
a) second exposure was too long.
b) development after the second exposure was too long.
c) first development was too long.

2 Image reversal does not take place. Picture develops normally. Reason: second exposure too short.

3 Flat negative print without lines. Possible reasons:
a) First exposure too short.
b) development before the second exposure too short.

4 Partly solarized picture. The picture turns grey instead of completely black. Lines occur only in very bright parts of the subject (such a partly solarized picture may be very effective). Reasons:
a) Second exposure short (but not as short as under 2).
b) second development short.

You can enhance pseudo-solarization effects by making a print of such a picture and giving it a second exposure in turn. Another print of it is again solarized and so on and so forth. Multi-stage solarization has the effect of converting all existing intermediate tones into lines and of the original lines first becoming double, quadruple, octuple... etc. lines.

It is not quite as straightforward as this: duplication affects only the thick lines, the thin ones remain unchanged. But since the

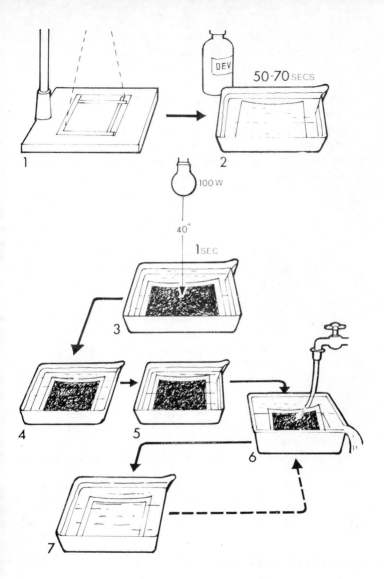

Solarizing print: 1, Expose normally. 2, Develop for about 50-70 seconds. 3, Expose print briefly to unsafe light and continue developing. 4, Stop bath. 5, Fixer. 6, Wash. 7, Bleach bath to clear highlights and rewash.

147

lines become thinner at each stage of duplication, this game cannot be continued ad infinitum.

It is nevertheless occasionally quite interesting to carry the solarization of a subject to the stage where all areas have been eliminated and only lines are left. With a contrasty, graphic subject without halftones, a silhouette for instance, you will achieve this already at the first stage. The more grey tones are present in your subject the more stages must be passed through until the line representation is obtained – and the more varied is the multitude of lines. Usually it is the second stage that is of the greatest interest. Here I like to keep the exposure a little shorter – about $1/2$ instead of 1 sec, when the areas that remain bright without second exposure will turn only grey instead of black.

On one occasion I had the brainwave to pseudo-solarize opal film as an experiment. Since on the normal opal film the lines came out darker than on ultra-hard paper and this special material is not very suitable for reduction, I was about to consign the sheet of film to the waste paper basket – when I made a puzzling discovery. Although the image on the glossy front was pseudo-solarized, the second exposure had been insufficient to influence the slightly unsharp image on the back; a normal positive was produced there (it is essential that the emulsion side should face upwards for the second exposure). During the transillumination the normal image will be superimposed by the pseudo-solarization effect. By copying you can transfer this effect combination negatively or positively to further sheets of opal film or bromide paper. The interplay of lines of a subject can, by the way, be made particularly varied if a pseudo-solarization series is started with opal film instead of ultra-hard paper.

A possibility of special attraction: insert such an opal film sheet in a flashing light box. The pictorial effect changes in the rhythm of the flashing light.

Pseudo-solarized composition on film

To obtain decent film pseudo-solarization effects I used many a hard material, finding negative easier than positive film, although the characteristic lines turned out rather grey. But since I in-

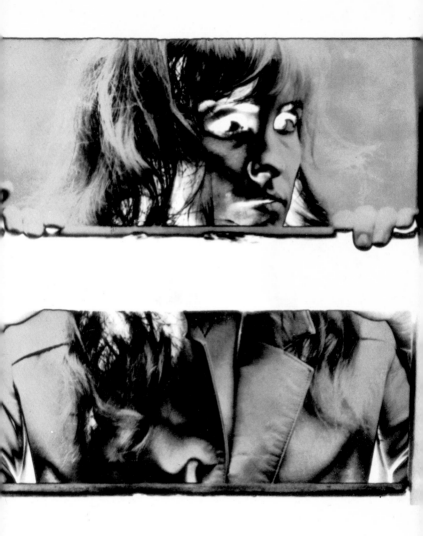

Contact print of opal film solarisation. The solarisation effect on the front emulsion of the opal film is superimposed on the thin positive image on the back. In the paper print, both are reproduced with reversed tonal values.

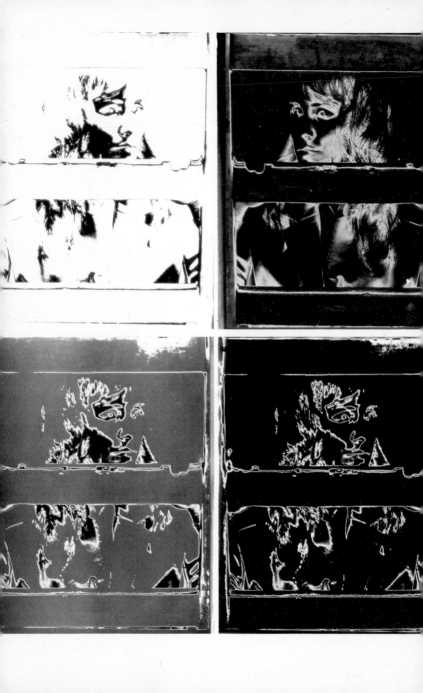

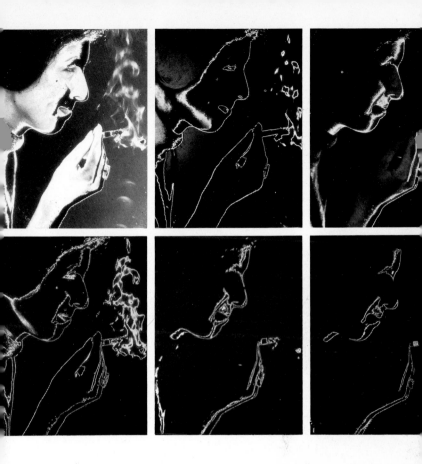

Opposite top right: First-degree paper positive solarisation, brightened in a reducing bath. *Top left:* A contact print from the solarised print. *Bottom right:* Second-degree paper solarisation by contact printing from print above. *Bottom left:* The same treatment but with a shorter second exposure gives partial reversal only.

Effect of copying on contour film. The top row shows first-degree contour copies with (from left to right) short, correct and generous exposure. The bottom row shows second-degree contour copies. The left-hand picture is from the top left original, the other two from the top right original. Overleaf is a print from the bottom row left above.

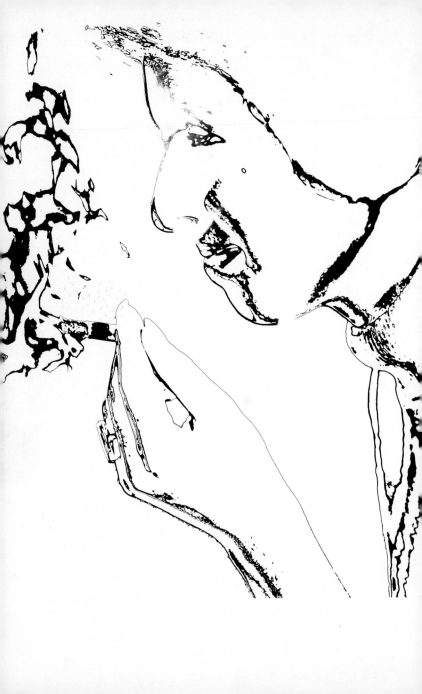

tended to make enlargements of the film, this did not matter a great deal. The only snag was that for enlarging the exposure times tended to be very long. I was given the tip to try a special line film. It worked perfectly. The pseudo-solarization lines became wonderfully transparent at the very first attempt.

When using this type of film for solarization effects, adopt the same attitude as with bromide paper: take my hints only as guidelines, which you must adapt to your special working methods. Concerning positive pseudo-solarization, the information in the previous section logically applies to the Sabattier effect on film. Another point may interest you: the white lines are formed always on the inside of the contour surrounding the black field in the original. If you want to outline a very finely structured object, the model of an engine say, with extremely precise contour lines, you must start with an original in which the object appears dark – i.e. from a transparency when the original object is dark, from a negative when it is light. And remember: interesting line formations will be obtained in fresh developer only. Strongly used developer merely reverses the image. It is worth finding out how far the pseudo-solarization method with strongly used developer (or developer to which potassium bromide has been added) is generally suitable for the standardized production of direct duplicate negatives.

Special contour film for graphic use

Imagine a special film, to be exposed like a normal sheet film normally developed and normally processed. Yet it produces a pseudo-solarization effect. No second exposure, no second development is necessary – wouldn't this be almost ideal?
Such a film does in fact exist, and is on the market as Agfacontour. It is an equidensity film and the same results can be achieved with it as with the pseudo-solarization of film – and a little more. The advantages are:

1 All uncertainties arising from the pseudo-solarization manipulations – especially the state of the developer and the timing relationship between first and second development and second ex-

posure – are eliminated. With Agfacontour it is possible to adhere to definite processing rules, which – in complete contrast with the Sabattier effect – always produce the same results.

2 The width of the lines can be quite precisely, yet simply controlled with filtering. Yellow filters are inserted in the filter drawer; the denser the filter the thinner the lines. Gelatine process filters are recommended.

3 The control of the effects with the filter often makes it possible to obtain effects at a single stage or with only one copying stage that could otherwise be produced only with multi-stage pseudo-solarization.

It is generally recommended to filter hard, graphic compositions only weakly so that they are outlined by a strong line. Pictures rich in tone values, on the other hand, must be strongly filtered so that as many areas as possible are replaced by lines, which, however, will be thin.

Agfacontour film is processed as follows: The darkroom illumination must be red because the material is orthochromatic.

The exposure time depends on the desired effect. Trial exposures are essential. Remember, however, that the material is rather slow. If lines are required on dark grey portions of the original picture, the film must be exposed 10 times longer than when only light grey portions are to form the lines. Dark picture areas require another 10 times exposure of the dark grey areas, and thus 100 x the exposure of light grey ones.

Agfacontour film must be processed in a special developer for 2 minutes at 20° C with continuous agitation. To improve the resolving power, the manufacturer originally recommended brush development.

I accordingly held the print in the developer with a pair of tongs, and moved a broad, flat brush to and fro. If you use new, improved Agfacontour film, brush development is no longer necessary.

The developer is supplied in two bags, A and B (to make 5 litres of solution). Dissolve part A in 3.5 litres of water. Add part B and make the whole up to 5 litres. Stir continuously; the chemicals dissolve only slowly. The unused working solution keeps for six months in brimful bottles, used working solution in a dish for two days. Never return the used developer to the bottle. Exhausted

developer is no longer capable of producing a pseudo-solarization effect; but you can still use it for processing hard process or document-copying material.

It is essential to immerse the pictures in a stop bath (2 per cent acetic acid solution) for at least 30 seconds. Otherwise bright orange-red stains will appear.

Agfacontour film rapidly exhausts the stop bath, which must therefore be replaced more often than usual.

Fix normally (bright-light inspection possible after 30 to 40 seconds). Rinse, pass through wetting bath, and dry as usual.

You may make a mess of your first experiments; the reasons may be as follows:

1 Pictures completely black: Exposure much too short. The tone (emulsion side) will be blue-black in this case.

2 Reproductions of perforation holes already surrounded by outlines: exposure much too long. Here the emulsion appears brown-black in tone.

3 Negatives look like transparencies, transparencies like negatives. Pseudo-solarization effect is absent:

a) Exposure slightly too long

b) developer exhausted

4 Only partial formation of lines. Large portions of the picture resemble a normal positive (or negative if the original is a transparency: exposure very slightly too long.

5 Large negative areas; line formation sparse or not at all prominent: exposure too short.

If you are keen on very fine lines you can – apart from using a dense yellow filter – copy the Agfacontour picture several times. The lines become progressively thinner. Most grey areas that may still be produced at the first stage have completely disappeared at the second stage. Black, very thin lines will be obtained when the contour picture is enlarged on ultra-hard paper or printed on hard film material.

Agfacontour film, incidentally, is of interest not only in graphic effects work. Zones of identical luminous density (so-called isophots) produced, for instance, by a flash reflector or a car headlamp can be precisely outlined; this would be a technological ap-

plication. Here is at least one suggestion of a comparatively simple method of evaluation: a comparison field of given luminous density is to be set up in the picture area (or mounted on a second picture) for an exposure on normal film material. During copying on Agfacontour film the exposure is balanced so that the comparison field is perfectly outlined by a sharp line.

Montage
and
Other Effects

The tricks we have discussed so far can generally be carried out with very simple means. I would not claim that the subjects in this chapter are very much more difficult, but they do call for some preparation and planning. For most experiments we need one or several prints. Even such a comparatively simple process as a relief print requires, as a first step, the production of a thin negative. Your extra effort will, however, often be rewarded with almost incredible graphic effects.

Montage registration methods

From the fact that I emphasize graphic compositions in this chapter you may deduce that by photo-montage I do not mean photographic forgeries. The same methods can sometimes be used for creative composition and abused for forging.

To change, by manipulations in the darkroom, the contents of a picture that is to have documentary value is irresponsible. In all other cases you may make use to your heart's content of the creative possibilities of photo-montage.

Montages are successful only when the problem of registration has been solved. To copy several pictures – usually contacts of a negative or a transparency – in precise register requires a lot of work. This work is either caused by every single montage when the pictures are fitted, or only once. For if you take a certain amount of trouble with the construction of a registration device, montage is all the easier for you.

I shall first tell you about three possible different methods. To be frank, I think really only the third method is feasible.

1 Two or more negatives or positives are mounted and enlarged together. This is possible with tone separation and with masking. The following points speak against this method:

Even if you mount pictures enlarged to 9 × 12 cm or 13 × 18 cm to produce contact positives or negatives it is not at all simple to line up the various pictures in really precise register. With small formats this is bound to fail.

For certain tone-separation processes the montage pictures must be produced in comparatively delicate grey tones. Most

other methods require hard negatives and positives; these are a little simpler to produce.

2 Mark all pictures with an ink or scratched cross on two opposite spots, as distant as possible from each other.

All negatives and positives required are contact-printed, including the registration marks. The various finished pictures are mounted. The masking frame is immovably fixed – if necessary with adhesive tape – on the baseboard. The bromide paper, too, must be firmly fixed to the support in the frame (drawing pins, contact adhesive). Below the masking strips of the frame a piece of opaque cardboard is mounted, also with adhesive tape; it completely covers the light-sensitive paper. The first picture is now projected on the back of the cardboard. The marking is exactly traced; the cardboard is now turned up and the picture exposed.

Each new picture in the negative stage must be projected on the cardboard cover. The marks on the film are brought into register with the tracings of the marks on the cardboard. Naturally only the position of the negative in the stage must be changed, never that of the masking frame.

You will find that having to align two, three, or four pictures in succession in precise register is an awfully tricky business. But in spite of all the care taken occasional "misfits" are unavoidable unless you use a device that overcomes these difficulties with the greatest of ease.

3 This registration device consists of two parts: an office punch and a copying holder.

The pins of the copying holder which accept the punched films or sheets of paper, must be matched precisely with the holes in the punch; the device is designed for the 13 × 18 cm format, but the effective picture areas can measure only 13 × 15 cm or 7 × 18 cm.

Naturally such a device can be built also for the 9 × 12 cm, the 18 × 24 cm format; a larger format means not only increased accuracy, but also increased cost. At any rate, all the intermediate negatives and positives produced from a 35 mm or 6 × 6 cm original must be matched with the registering device for size. To me, 13 × 18 cm seems to be the right compromise solution, but some enlargers accommodate 9 × 12 cm.

The punching device consists of a plywood plate measuring about 13 × 24 cm × 8 mm. An office punch is screwed on each narrow side so that the punches face each other. The distance between the punch rods is about 16 cm. A 13 × 18 cm sheet can be slid between them without difficulty. Since the base area of the punch is about 4 mm high, I mounted an 11 × 13 cm plywood sheet, thickness 4 mm in the intervening space so that the entire supporting area is fairly level.

Note: the bottom lids must be removed from the punches, which should protrude slightly beyond the edge of the narrow sides of the base plate to allow the removal of the "confetti".

The copying holder consists also of an 8 mm thick 23 × 32 cm sheet of plywood. It may be larger if necessary. You must be able to attach it to the baseboard with clamping screws so that it is absolutely rigid. (For some operations I even screw it to the baseboard). It would of course have been possible simply to knock four steel pins into the baseboard to accept the punched sheets; but this would not have assured accuracy of the distances. Four angle pieces with a guide slot and small round hole on the underside are screwed to the board with wing nuts; they can be adjusted when the wing nuts are loosened, and firmly clamped in position when the nuts are tightened.

A few steel nails are cut to size and driven into the above-mentioned holes. A sturdy sheet of film is punched, the punched holes dropped on the nails and the angle brackets aligned so that the sheet is straight and under slight tension. The thickness of the angle brackets was compensated with a 13 × 13 cm sheet of plywood of the same thickness, which was fixed between them.

This is how the method works: the original negative or positive, of which two or more copies must be made, is inserted in the negative stage, the copying holder is fixed on the baseboard. All film sheets are punched, placed on the holder, and exposed. Important: During punching, depress the levers of the two punches simultaneously.*

After all the "intermediate products" are processed, a punched sheet of paper or a film is placed in the holder for the final montage. Now one of the intermediate film enlargements after the other is superimposed – if necessary several at a time – and the contact print exposed. A minor disadvantage of this method is

that as the distances between the four holes are not exactly the same, the intermediate film enlargements must be placed emulsion side up for copying exactly as for enlarging. But this is not disturbing, especially not with the very thin and clearly transparent line type of film. If 9 × 12 cm film and only two holes are used, the film can also be turned round for copying and placed emulsion side down on the bromide paper.

In order always to align punch and copying holder correctly to each other the front right-hand corner of both machines should be marked. This arrangement has been found extremely reliable and can be used even for masking, either with a thin, grey positive mask (for contrast reduction), or a hard one for isolating an object. Negative and mask are simply placed together on the paper to be exposed.

Tone separation and posterisation

So-called tone separation is one of the simplest types of montage. As a rule, only four intermediate enlargements on film – two positive and two negative ones – are required for this purpose. If possible, the devices just described should be used for such experiments.

First make a transparency, hard and with a short exposure (shadow transparency) if possible on line film. It should be very light. Only the darkest shadows should still be visible as traces.

As the next step produce a very soft transparency with generous exposure. The slide should be almost completely dark grey. Only the highlights should stand out a little (highlight transparency). Make negatives of both slides on the copying holder. Whether these negatives are a little harder or softer depends rather on your taste and on the desired effect.

When the two negatives are, successively and in precise register, contact-printed on a sheet of paper, the highlight negative should receive little, the shadow negative generous exposure.

Tone separation removes the middle tones from the picture, and lets the contrast between the light grey and the dark grey tones appeal to the viewer. This is surprisingly effective with many subjects.

It is an irritating feature of all montages that before you can proceed you always have to wait for the films to dry. But special materials for reproduction dry surprisingly quickly – with a fan heater within as little as half an hour.

Unlike tone separation, the rather similar posterisation has a genuine graphic effect. It can, with the aid of the registering device, be composed of 2, 3 or even more negatives. In certain conditions only two steps need be used.

The various steps for a three-part isohelie:

1 Make three enlarged transparencies of a negative, with exposures as different as possible, on very contrasty material. One should contain only the darkest tones, the second the dark and medium tones, and the third dark, medium, and light tones except white and very light grey.

2 Of each of these transparencies contact-print also a very hard negative. If you copied these negatives, which contain only a few grey tones, together now you would already obtain quite interesting pictorial effects. Not always, but often it will be better to "squeeze out" even the last traces of grey tones with another copying run.

3 Make another transparency of each of the three negatives, which will be harder still.

4 The new transparencies again produce three new, extremely hard negatives.

5 Copy the three negatives successively on bromide paper in the copying holder. The negative with the highest density proportion is exposed longest. Its whites can be reproduced black. The negative with the medium proportion of black is exposed somewhat shorter. Its whites should appear medium grey.

The negative with the fewest densities must produce a light grey tone and must be given an even shorter exposure.

You will have to sacrifice three or four trial strips before you have matched the various exposures satisfactorily.

Posterised effects can be considerably improved with the aid of screen foils. If you introduce different screen foils between the negative and the paper for all three contact printing runs you can generally increase the exposure. After all, the various zones

should now differ in the screen structure instead of in the grey tones. But interesting effects will also be obtained if screens are used in only one or two printing runs.

Double exposure and classical photo-montage

To combine subjects from two or more photographs you can use three methods:

1. The simple sandwich method without registering device
2. The simple multiple exposure (without registering device)
3 Masking photo-montage (with registering device)

For the first method, two different negatives but of related subjects with light backgrounds are superimposed and together inserted in the negative stage. The result is an enlargement with a dark background. Occasionally one can find two negatives which, superimposed, contain no intersecting details. This will, however, be exceptional. Intersections produce "ghost images" or an X-ray effect.

For the second method, two different but harmonizing negatives with dark backgrounds are printed successively on a sheet of bromide paper. Different enlarging scales can be chosen, if desired. In addition details of the picture can be held back or printed up with dodgers, sheets of cardboard with holes, or similar devices. Two subjects can thus be combined with each other without intersections, on a light background. If you start with two black-and-white or colour transparencies with dark backgrounds, you will first produce a double-exposure negative from which you will obtain a picture with a dark background.

To match the details of the two pictures harmoniously it is advisable to place an opaque piece of cardboard on the bromide paper after the first exposure, to project the first negative once more and to trace the most important outlines on it. The second negative is now inserted in the negative stage and the enlarging scale so altered that the outlines of the subject harmonize with the tracing.

The combination of two subjects by the masking process is the

most advanced of the three methods. Intersections do not occur. With appropriate subjects the fact that they are parts of a photo-montage will go quite unnoticed. Let us call the subject into which something is to be printed picture No. 1, the subject from which a part is taken and transferred to picture No. 1, picture No. 2. Of the latter, an enlarged intermediate negative is made, if necessary, in the copying holder via intermediate positive. Without adjustment of the copying holder or a change in the position of the negative in the negative stage, another, very hard negative is produced. This negative, or, if more suitable, a hard copy transparency, serves as a basis for an isolating mask.

Isolate with opaque paint and cover with stripping varnish the subject detail to be transferred. If necessary the result can once again be copied in the registering device. What is, however, essential is a transparent outline trace on completely black background of the detail to be transferred. (It cannot be precisely laid down whether, how, and how often a copy is necessary. It depends on which copying stage can be retouched best without complicated tracing). Now expose a sheet of film in the registering device first to a positive of picture No. 1 and then in contact with the hard mask (with negative outline). The result: a negative of picture No. 1 with additional dark outline of picture No. 2. This is followed by the final montage in two stages:

1 First exposure in contact with the above-described negative (picture No. 1 with printed-in silhouette of picture detail No. 2).
2 Second exposure in contact with the negative No. 2 and the superimposed black background mask (with light detail outline).

All this sounds far more complicated than it actually is. Basically this method can even be used for colour montage. Here, too, the masks consist of hard black-and-white material.

Pattern pictures

A symmetrical object has at least two identical, but mirror-inverted associated parts. But we distinguish between several kinds of symmetry, such as, for instance:

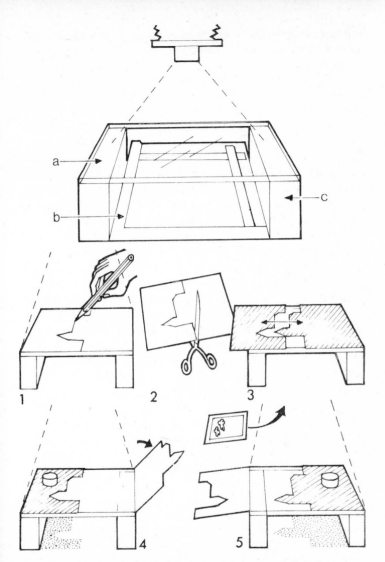

Printing from two negatives: **a**, plate glass. **b**, masking frame. **c**, wood blocks. Procedure: 1, Place sheet of paper on glass and trace outline for masks from image focused on baseboard. 2, Cut masks. 3, Tape masks at·opposite edges. 4, Expose two negatives alternately with appropriate masks folded back.

1 Bilateral symmetry, where there is only one axis of symmetry dividing the two symmetrical parts. Examples: butterfly, leaf, amphora, bottle.

2 Central symmetry, with several axes of symmetry (central symmetry includes multi-axial symmetry). All axes always intersect with the centre of the figure. Examples of biaxial central symmetry: rectangle, rhombus, oval, the planet Saturn. Examples of tri-axial central symmetry: equilateral triangle, bud of a poppy flower seen from above, wood sorrel from above. Examples of quadri-axial central symmetry: square, cross. Examples of 5-axes central symmetry: starfish, skeleton of sea urchin, pentacle. Examples of multiaxial central symmetry and symmetry with an infinite number of axes: Sunflower, snowflake, wheel, circle, star.

3 Multiple symmetry. Features that are already symmetrical are arranged side by side or superimposed or reflected, so that new, higher-order-symmetry features are produced. This is one of the most interesting methods of ornamentation and of structuring. If multiplication is developed in only one direction, a ribbon will result. Examples: paper chain, chains of cowri shells of equal size, of coins, of pearls, an egg-and-dart (architectural ornament), and many other ribbon ornaments.

Structure will be produced if the multiplication is multi-directional. Example: chess board, kaleidoscope effect, honeycomb, fabrics, coffered renaissance ceilings.

The kind of symmetry most important to us is also the simplest: obviously bilateral symmetry (with a vertical axis) is the most impressive variety. Does our aesthetic perception perhaps receive powerful impulses from our awareness of our own body structure?

You can best experiment with symmetry with hard copies of graphic designs. Particularly well suited are pseudo-solarized pictures completely dissolved into contours or Agfacontour copies. On bromide paper, such outline shapes can be printed on top of each other, resembling a double exposure (for the second exposure the film is side-reversed in the negative stage), or they can be printed side-by-side; here, too, a shape is exposed laterally reversed, so that it looks like a mirror image.

The austerity of symmetry is slightly softened if you make a nega-

tive print of one of the two figures, creating a strong light/dark contrast. The use of different screens for the two parts also detracts a little from the symmetry.

If you now print several such symmetrical double figures side by side, you will have multiple symmetry, and in the end a symmetrically structured ornamental ribbon.

If you go a step further and produce a second ribbon above the first (it must, however, be upside-down), you will be well on the way to converting your figure into a component of an ornamental plane. A block of four would be a central symmetrical (most probably bi-axial) structure.

Multi-axial central symmetrical designs can be produced with the aid of a turntable. I use the rotating masking frame tilting device of my Leitz Focomat for this purpose. The centre of the paper must coincide with the centre of rotation. The comparatively little enlarged projected image fills only about a quarter of the area of the paper. Everything must be arranged so that the centre of rotation lies directly under a corner of the projected image area.

Now subdivide a full rotation into 4, 6, 8, 12, 16 or even more steps. Whenever the photo-roundabout has turned to the next step, expose. Pencil marks on the bromide paper, checked with red-filtered light, help to rotate it always through the same angle. By the way – the circular pattern thus produced will be strictly symmetrical only if the individual figure itself is already symmetrical and its axis of symmetry can be extended to the centre of rotation. But attractive circular patterns will also be produced without symmetry.

Even simpler, and perhaps still more effective than the experiments with symmetry, is playing with concentric patterns. These have the same shape, the same position, and the same centre, but their sizes are different. A three-dimensional classical example is the nest of Russian wooden dolls.

It is best to start the "concentric experiment" with a pseudo-solarized silhouette picture (because it consists of a single light outline). This original is first exposed on the bromide paper at a very small enlarging scale. Now push the enlarger head a little higher and make the next exposure. You can continue this process for 5, 6 and even more exposures.

The exposure times, naturally, must be extended slightly each

time the enlarger head is raised further. Likewise, with non-auto-focusing enlargers focusing must be corrected for each part-exposure with the aid of the red filter.

If the position of the enlarger head is left unchanged, but the masking frame moved a little to the right, left, top, bottom, diagonally or successively in several directions before each part exposure, you will obtain a structure which, although not symmetrical, is nevertheless full of interest, consisting as it does of identical and as a rule intersecting shapes in parallel arrangement.

Processing
Films

Now you know all about the practice of enlarging, you can without fear start to process your own films.

Doing your own processing is not all that important if you use normal medium-speed films. But ultra-fast films, document-copying material or special material such as infrared films should be treated in a special manner. Whether you want to do this yourself or have them expertly developed in a specialized darkroom at an extra charge is up to you. For the creative evaluation of your negatives it is at any rate more important that you should be thoroughly familiar with the methods of enlarging than bother unduly with film development. Nevertheless, you should learn something about this aspect of your hobby, too, at least in a condensed form.

Equipment for black-and-white processing

The equipment for film processing is far less expensive than all the gadgets you need for enlarging. All you require is:

1 A complete developing tank (if necessary with two extra containers and one extra lid)
2 Negative developer
3 Rapid fixing salt (the same as for enlarging)
4 Film clips (plastic laundry pegs will do)

Your enlarging outfit already contains items useful for development:

5 Thermometer
6 25 cc measure
7 1000 cc measure
8 Wetting agent

A darkroom timer is useful but not essential for film developing. Darkroom lighting is necessary for processing line films only. For all other films development is by time.

Developing tanks differ in many respects. Some accept roll film, others 35 mm film, others both. Some accept only one film, others two and even more. Multiple tanks are economical only for

large-scale consumers. Tanks may be made of steel or of plastics.
The inserts for threading the film may be transparent plastic or
stainless steel spirals. Some tanks allow the film to be loaded in
daylight.

There is a certain amount of disagreement about the respective
advantages and disadvantages of metal and plastic tanks: to
make the choice easier for you, I am tabulating them below.

METAL AND PLASTIC TANKS COMPARED

	Metal tank	Plastic tank
Heat transfer	Easy to warm, but also cools rapidly. Exact maintenance of temperature possible with a 20°C water bath	Insulating effect of the plastic material. Temperature fluctuations are not noticeable during development (important during travelling). Correction of too low or high temperatures takes considerably longer than in metal tanks
Development of infrared films	Metal screens any radiation	Plastics transmit infrared radiation. During development any light, even darkroom light, as well as brightly radiating heaters must be switched off without fail

The threading, especially of roll film, into spirals is sometimes
a little tedious, mainly because the whole procedure must take
place in pitch darkness. Trial runs in daylight with a piece of scrap
film are well worth while. Pick up the film along the edges, slightly
pressing them together, and introduce it into the outer thread of
the spiral, the emulsion side facing inwards. This enables you to
take the outermost turn of the film between thumb and middle
finger, carefully assisting the entry of the film into the spiral. In
most spirals, the edges of the film protrude in at least one sector
on the top; here, the thumb can be used to coax the film further
into the spiral.

All this sounds very complicated, but if the spiral is dry, threading is comparatively easy.

Wet spirals: it is easier to get a camel through the eye of a needle than film into a wet plastic spiral – unless it is fitted with the modern automatic threading device. Internally rotating spirals take the adventure out of film threading. Transparent plastic and wire spirals, by the way, have the advantage that the film need not be removed from them for the second exposure, necessary, for instance, for reversal development.

Black-and-white negative development

The whole subject of development is already known to you because what happens during paper development also happens during negative development.

Development, fixing and rinsing are usually carried out in the same tank. One solution is poured out through an opening, and the next one poured in. I prefer to work with three tanks. One is for the developer only, the second for the rinse only, and the third for the fixing solution only.

This has the advantage that splashing about with various baths is eliminated and contamination more easily prevented. Tanks into which one solution after another is poured, such as daylight tanks where this is unavoidable, must be thoroughly cleaned after use.

With my three-container system the 1000 cc fixing bath remains permanently in its vessel. For each film fixed I mark it with crayon; after the tenth mark I pour the bath away. (Made-up fixing solution keeps practically indefinitely).

Regarding negative developer, I am a fanatical devotee of the "one-time" developer. Make it up; develop one or several films in it simultaneously; pour it away.

Strict maintenance of the correct temperature is even more important in negative than in paper development. The recommended temperature is generally 18 or 20° C.

Cooler developers work more slowly. They cause a certain loss of film speed which cannot always be recoverd by an extension of the developing time. At high temperatures development must

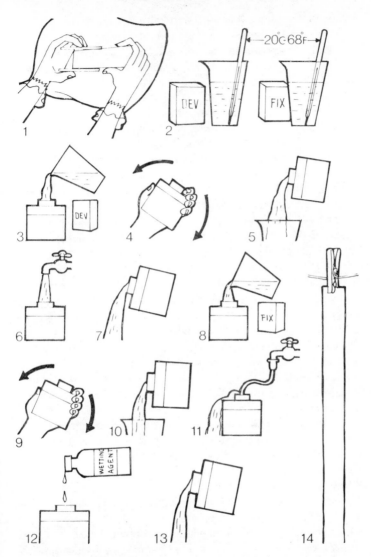

Black-and-white processing: 1, Load spiral and place in tank. 2, Prepare solutions. 3, Pour in developer. 4, Agitate. 5, Pour out developer. 6, Fill tank with water. 7, Pour out water. 8, Pour in fixer. 9, Agitate. 10, Pour out fixer. 11, Wash. 12, Add wetting agent. 13, Pour out water. 14, Dry.

be curtailed. Since higher temperatures cannot always be avoided in the summer or in hot countries it is nice to know that development can still be carried out at 25° C. Still higher temperatures present the risk that the gelatine layer will become detached from its base.

Attempts have been made for some time to squeeze even more speed out of films by the use of higher temperatures.

The temperature of other solutions – fixing bath and water – may fluctuate a few degrees either way. There is no need to exaggerate either accuracy or inaccuracy but the temperature should not be lower than 18° C.

Adhere to the developing times recommended by the manufacturers of the chemicals. Too short a time produces flat, too long a time hard, contrasty negatives. This effect can be put to good use when the film mainly consists of contrasty or of flat subjects. Reproductions of pencil drawings will therefore receive longer, contre-jour subjects shorter development.

The individual makes of film behave differently with the various types of developers. But all manufactures of film also produce developers. Instructions for their use, however, as a rule contain information only about the development of films from their own stable. This makes it appear as if a union between an Agfa film and a Kodak developer, for instance, produces only inferior results. But appearances are deceptive. Some rules of thumb may help you to make, if necessary, rapid tests with exposure and processing materials of different origins.

Faster films must be developed considerably longer than slower ones. Underexposed films can be saved by an extension of the developing time. There is, however, little point in carrying this beyond four times the normal period.

Stronger developer concentration requires a cutting down of the developing time. Otherwise the results will be considerably harder. (To develop flat films more vigorously, either the time can be extended or a stronger concentration of the developer used). The weaker the concentration, the finer the grain. Nevertheless, developers should be strongly diluted only for slow and medium-fast film. For fast and ultra-fast films the developing time would be unduly extended on the one hand, and the contrast reduced too much on the other.

174

I must, however, sound a note of caution here. Full advantage can be taken of this information only if the type of developer used is adaptable.

Developing tanks must be vigorously moved during film development, to ensure that fresh developer is constantly reaching all parts of the film. This is known as agitation. The best method is the so-called agitation by inversion. The loaded tank is first of all firmly tapped on the table to dislodge any air bubbles adhering to the film. Turn the tank upside down 10 times during the first minute of development, then every 30 sec.

Recently, tank-inverting machines have reached the market, which ensure particularly even development results. If you invert ancient types of tanks, liquid may be spilled. You can overcome this by development in complete darkness, leaving the tank open, and taking out the film spiral and letting it drop back once every 30 seconds. Here you need a darkroom timer because you cannot watch the time very well on a wrist watch.

A short rinse in ordinary tap water follows the development. I use a stop bath only in special cases (Agfacontour film, solarization effect). Then the fixing solution is poured in. Invert the tank occasionally also during fixing, but especially frequently and vigorously at the beginning of the fixing process. The fixing time is stated on the pack.

When in doubt open the tank after 1 to 2 min. fixation. If the film is completely clear, continue fixing it as planned. If it still shows some milkiness wait till this has gone; from then on, leave the film in the fixing solution for the same period of time it took to clear; the clearing time should be exactly half the required fixing time. I do not remove the film from the spiral for assessment immediately after fixing. There is a considerable risk of scratching it and dirt settling on it. I have patience for another 30 minutes, i.e. the time for the final wash, during which the film should be exposed to running water in the tank.

Your patience will be particularly tried when the water is rather cool – because this means an extension of the washing time. Finally the film is bathed in wetting solution for 1–2 minutes.

If you use no wetting agent, your film will show drying marks; if you use too high a concentration, it will show wetting agent marks. Although both can be removed with a damp piece of cha-

mois leather after the film is dry, to avoid the risk of scratching, it is best not to have to wipe the film down at all.

For drying, hang the film on a line with a laundry peg, weighting its other end with a second peg. The dry film is cut into strips of six and kept in a negative sleeve. Do not roll it up and push it into a tin. Such treatment is deplorable.

Faults
and
Remedies

FAULT TRACING LIST, NEGATIVE DEVELOPMENT

Fault	Cause	Remedy
Negative too dense	Overexposure Development too long	Give less exposure Shorten development
	Developer too warm	Adhere to correct temperature
Negative too contrasty	Development too long Developer too warm	Shorter development, Adhere to correct Temperature
Negative too thin	Underexposure Development too short	Give more exposure Develop longer
	Developer too cold Developer exhausted	Temper developer Use fresh developer
Negative too flat	Developer too short	Develop longer
	Developer too cold Developer exhausted	Control temperature Check developer yield
Negative fogged	Film pre-exposed Expiry time exceeded Extreme over-development and much too high temperature	Develop film in darkness Use fresh film Time-temperature control
Dichroic fog (opalescent coloured layer on film)	Contamination of solutions	Avoid transfer of developer to fixing bath and vice versa
Emulsion strips from support	Solutions too warm	Do not turn on the hot water tap for rinsing
Bands and schlieren	Lack of agitation	More vigorous agitation of the film during development
Cloudy densities	Developer insufficiently mixed	Mix developer more thoroughly or leave it more time to "mature" after making it up

Fault	Cause	Remedy
White dots or patches	Air bubbles adhering to the emulsion during development	Plant the tank firmly on support at the beginning of the development
	Splashes of fixing solution on the emulsion before development	More cleanliness during work
Parts of the negative have reversed to positive	Film exposed during development	Work in darkness
Grey-white drying marks	Film was dried without wetting bath, or splashed with water after drying	Use wetting bath, re-immerse in wetting bath

FAULT-TRACING LIST, PAPER PROCESSING

Fault	Cause	Remedy
Grey fog	Paper over-age	Use fresh paper
	Paper pre-exposed	Protect papers against light
	Darkroom illumination too bright	Use weaker lamp, a different safelight screen, or increase the distance between lamp and workplace
	Developing time too long or developer too warm	Control developing time with darkroom timer. Control developer temperature with thermometer
Pictures too flat	Exposure too short	Expose longer
	Development too short	Adhere to correct developing time
	Developer too cold or exhausted	Control temperature Use fresh developer
	Paper prints pre-exposed or darkroom light too bright	Protect papers against light. Use yellow–green darkroom light

Fault	Cause	Remedy
Pictures too dark	Overexposure	Give less exposure
	Developer too warm	control temperature
Highlights burned out	Paper too long in fresh fixing solution	Adhere to fixing times
Yellow fog through developer	Development too long or solution too warm	Control time and temperature
	Fixing bath carried over into developer	Avoid this contamination
Yellow fog through stop bath	Print too long in the exhausted bath	Cut down time in intermediate bath
Yellow fog through fixing bath	Fixing bath exhausted or contaminated with developer	Use fresh fixing bath
	Too little agitation of the print	Agitate prints more vigorously
Black-and-white rings	Newton's Rings	Re-insert film, introduce paper mask between film and pressure plate

Index